Glasgow & Clydeside

Glasgow & Clydeside

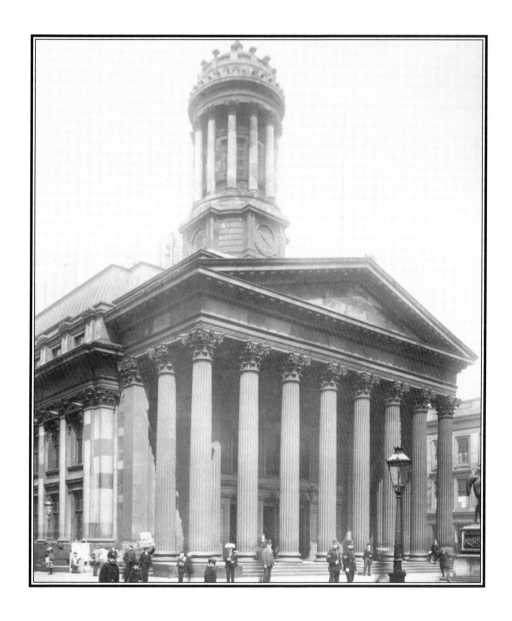

Clive Hardy

Waterton Press Limited

First published in the United Kingdom in 1998 by
Frith Publishing an imprint of Waterton Press Limited
Reprinted in 1999

British Library Cataloguing in Publication Data

Clive Hardy
Glasgow & Clydeside

ISBN 1-84125-012-0

Reproductions of all the photographs in this book are
available as framed or mounted prints. For more
information please contact The Francis Frith Collection at
the address below quoting the title of this book and the
page number and photograph number or title.

The Francis Frith Collection,
Frith's Barn, Teffont, Salisbury, Wiltshire, SP3 5QP
Tel: 01747 855 669
E mail: bookprints@francisfrith.com

Typeset in Bembo Semi Bold

Printed and bound in Great Britain by
WBC Limited, Bridgend, Glamorgan.

Contents

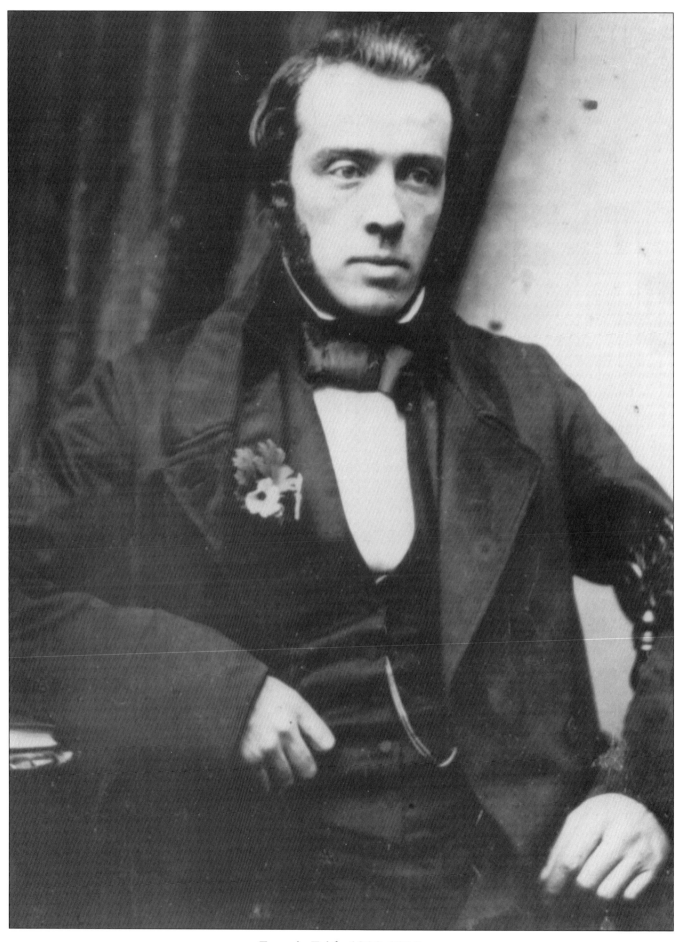

Francis Frith 1822-1898

Introduction

Francis Frith: A Victorian Pioneer

Francis Frith, the founder of the world famous photographic archive was a complex and multitudinous man. A devout Quaker and a highly successful and respected Victorian businessman he was also a flamboyant character.

By 1855 Frith had already established a wholesale grocery business in Liverpool and sold it for the astonishing sum of £200,000, equivalent of over £15,000,000 today. Now a multi-millionaire he was able to indulge in his irresistible desire to travel. As a child he had pored over books penned by early explorers, and his imagination had been stirred by family holidays to the sublime mountain regions of Wales and Scotland. "What a land of spirit-stirring and enriching scenes and places!" he had written. He was to return to these scenes of grandeur in later years to "recapture the thousands of vivid and tender memories", but with a very different purpose. Now in his thirties, and captivated by the new science of photography, Frith set out on a series of pioneering journeys to the Middle East, that occupied him from 1856 until 1860.

He took with him a specially-designed wicker carriage which acted as camera, dark-room and sleeping chamber. These far-flung journeys were full of intrigue and adventure. In his life story, written when he was sixty-three, Frith tells of being held captive by bandits, and fighting "an awful midnight battle to the very point of exhaustion and surrender with a deadly pack of hungry, wild dogs". He bargained for several weeks with a "mysterious priest" over a beautiful seven-volume illuminated Koran, which is now in the British Museum. Wearing full arab costume, Frith arrived at Akaba by camel seventy years before Lawrence of Arabia, where he encountered "desert princes and rival sheikhs, blazing with jewel-hilted swords".

During these extraordinary adventures he was assiduously exploring the desert regions of the Nile and recording the antiquities and people with his camera, Frith was the first photographer ever to travel beyond the sixth cataract. Africa, we must remember, was still the "Dark Continent", and Stanley and Livingstone's famous meeting was a decade into the future. The conditions for picture taking confound belief. He laboured for hours on end in his dark-room in the sweltering heat, while the volatile collodion chemicals fizzed dangerously in their trays. Often he was forced to work in tombs and caves where conditions were cooler.

Back in London he exhibited his photographs and was "rapturously cheered" by the Royal Society. His reputation as a photographer was made overnight. His photographs were issued in albums by James S. Virtue and William MacKenzie, and published simultaneously in London and New York. An eminent historian has likened their impact on the population of the time to that on our own generation of the first photographs taken on the surface of the moon.

Characteristically, Frith spotted the potential to create a new business as a specialist publisher of photographs. In 1860 he married Mary Ann Rosling and set out to photograph every city, town and village in Britain. For the next thirty years Frith travelled the country by train and by pony and trap, producing photographs that were keenly bought by the millions of Victorians who, because of the burgeoning rail network, were beginning to enjoy holidays and day trips to Britain's seaside resorts and beauty spots.

To meet the demand he gathered together a team of up to twelve photographers, and also published the work of independent artist-photographers of the reputation of Roger Fenton and Francis Bedford. Together with clerks and photographic printers he employed a substantial staff at his Reigate studios. To gain an understanding of the scale of Frith's business one only has to look at the catalogue issued by Frith & Co. in 1886. It runs to some 670 pages listing not only many thousands of views of the British Isles but also photographs of most major European countries, and China, Japan, the USA and Canada. By 1890 Frith had created the greatest specialist photographic publishing company in the world.

He died in 1898 at his villa in Cannes, his great project still growing. His sons, Eustace and Cyril, took over the task, and Frith & Co. continued in business for another seventy years, until by 1970 the archive contained over a third of a million pictures of 7,000 cities, towns and villages.

The photographic record he has left to us stands as a living monument to a remarkable and very special man.

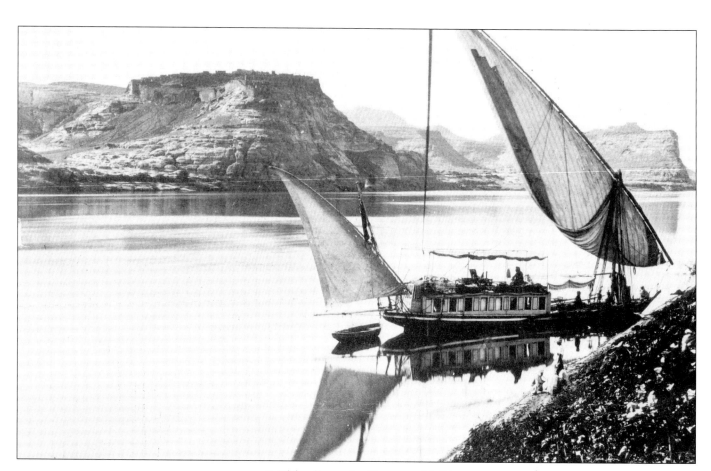

Frith's dhow in Egypt *c.*1857

GLASGOW

It was the Act of Union with England which opened up Glasgow's potential as a port and industrial centre. Glasgow was ideally situated to take advantage of the trade with the American colonies, becoming the focus of the import and re-export of tobacco.

American requirements for manufactured goods such as textiles transformed Scotland's linen industry to such an extent that by 1778 there were 4000 handlooms in Glasgow alone. After the War of Independence, the price of flax rocketed and cotton was looked upon as a viable alternative. By 1787 no less than nineteen cotton mills were at work, rising to over two hundred within a few decades.

From the 1750s, English iron founders discovered that it was cheaper to ship ore to Scotland for smelting due to the availability of cheap charcoal. However, it was the discovery in the early 1800s of a local source of top quality ironstone that gave the industry a much-needed kick up the backside. By 1847 Scotland was producing 25 per cent of Britain's iron.

Glasgow had always been a go-ahead sort of place. During the late seventeenth century a number of businesses had been established including, a soap works using whale blubber (1673), a sugar refinery (1675), a rope-works (1696) and a glass-works in 1700. There were also several candle factories and a number of coal-pits.

It was the advent of steam-power that saw the development of Glasgow's two greatest industries, shipbuilding and railway locomotives. The shipyards included Lobnitz & Co., W Simons & Co., John Brown & Co. Clydebank, A & J Inglis Ltd and D & W Henderson & Co. Railway locomotives were manufactured by the North British Locomotive Co, an amalgamation of three companies employing around 7000 workers. In total the NBL built around 20,000 railway locomotives for customers worldwide.

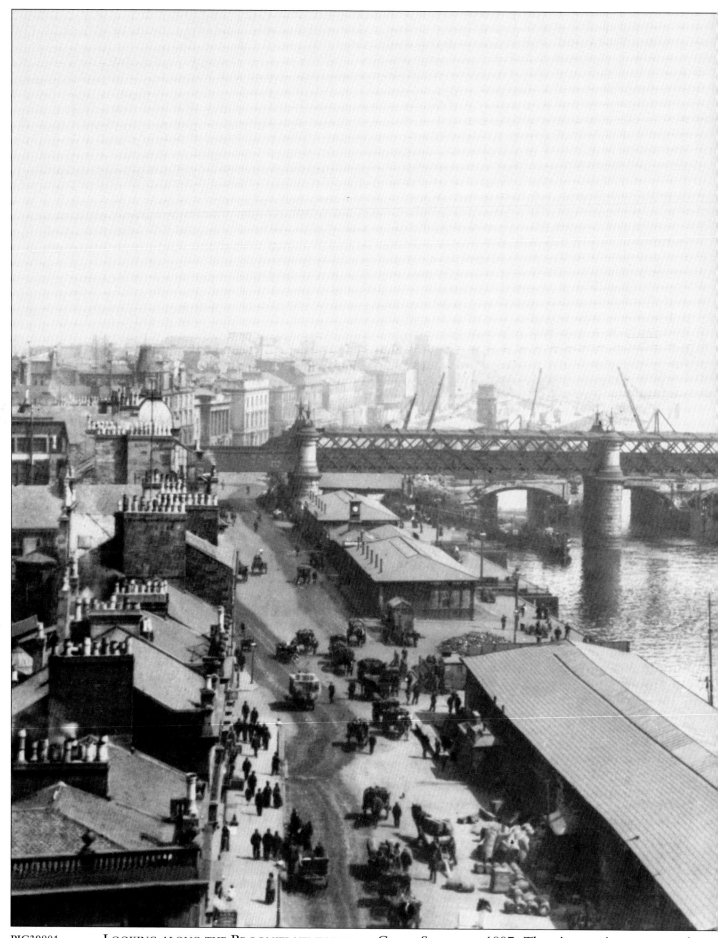

PIC39801 LOOKING ALONG THE BROOMIELAW TOWARDS CLYDE STREET IN 1897. The picture gives us a good view of the railway bridge serving Central Station, whilst immediately behind it work is underway on rebuilding Glasgow Bridge. It is also possible to make out the towers of the suspension bridge situated a little further along the river. On the far bank are some of the warehouses along Bridge Wharf.

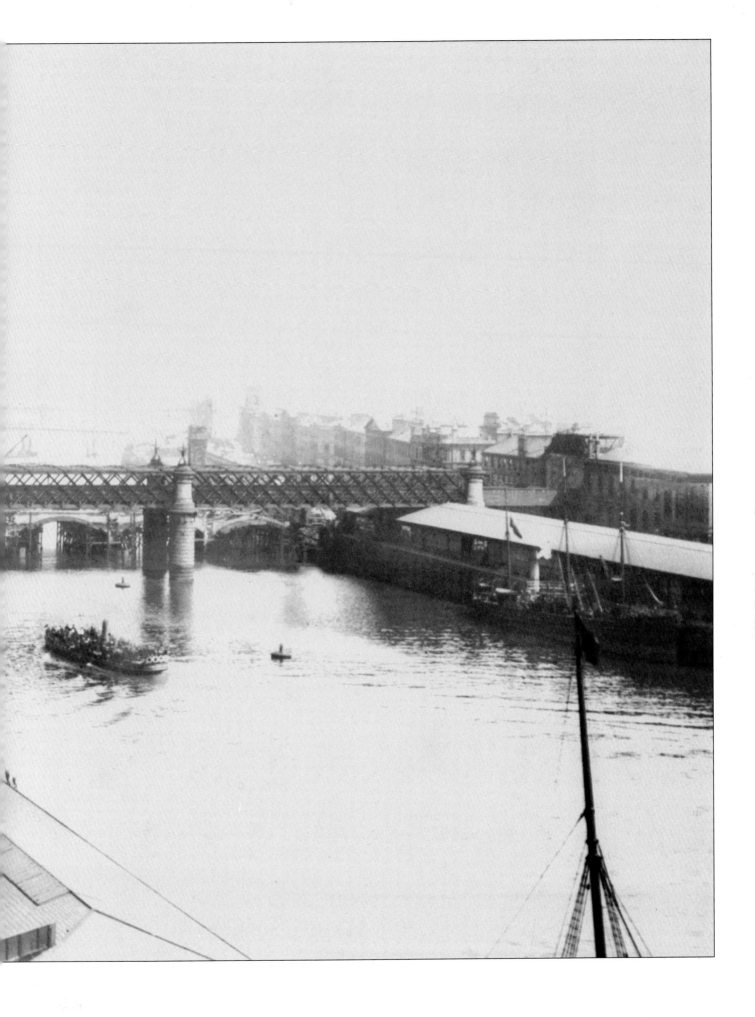

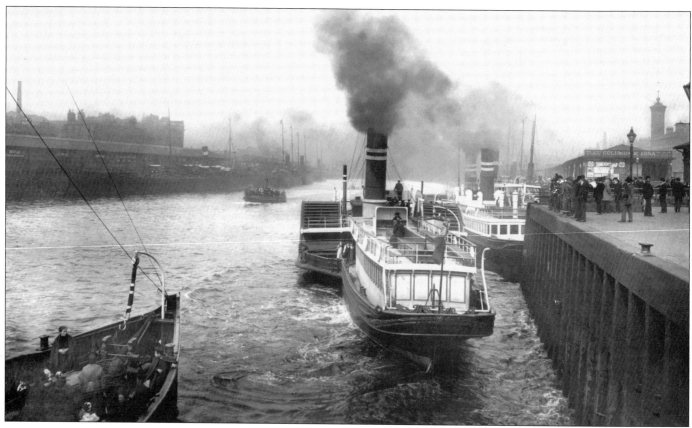

PIC39799 STEAMBOATS. The Glasgow & Inverary and the Lochgoil & Lochlong Steamboat Company's sported the same colour scheme. Black hull and paddle boxes with white saloons and lifeboats. The funnel colour was red, with two white bands enclosing a black one. The top of the funnel was also painted black. This picture was taken at the Broomielaw in 1897.

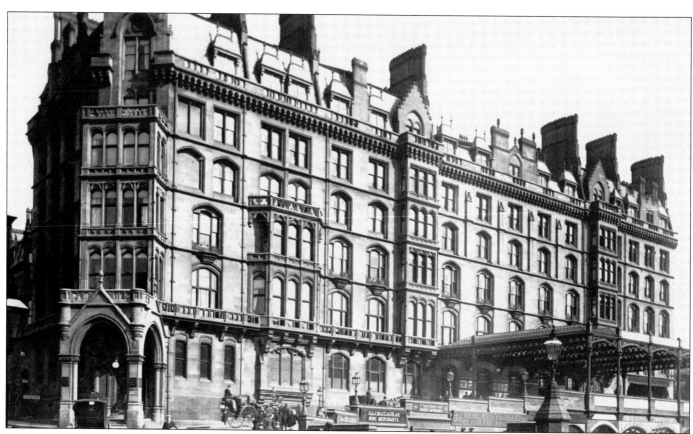

PIC39792 ST ENOCH, 1897. The Glasgow & South Western and the Caledonian Railway competed with one another for traffic, particularly on the Clyde coast and across to Ardrossan. However, for a number of years they shared a Glasgow terminus at Bridge Street, but in 1879 the G&SWR opened St Enoch Station and the Caledonian moved to Glasgow Central. This picture shows St Enoch in 1897. The station hotel was ranked as one of the best in Glasgow, and the 1906 price list included rooms at 4s a night, breakfast or luncheon 3s, dinner 5s.

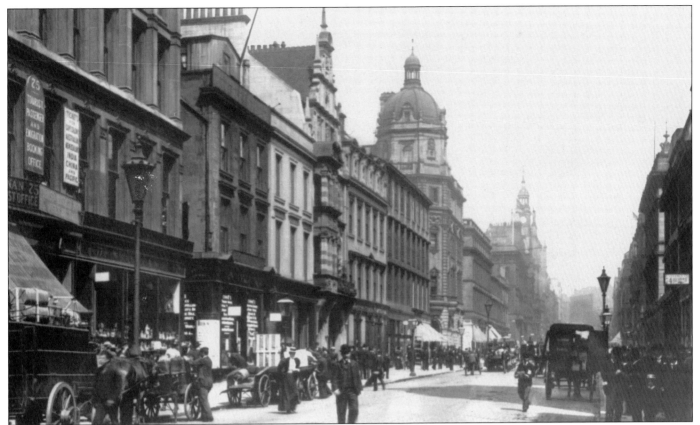

PIC39767 BUCHANAN STREET WAS ONE OF THE BUSIEST THOROUGHFARES IN THE CITY. At the one end was the Caledonian Railway station where trains could be caught for Oban, Perth and the north, at the other was St Enoch Station. Buchanan Street was also a great place to eat out, with several top restaurants including, Queen's at no.70, and Ferguson & Forrester at no.36.

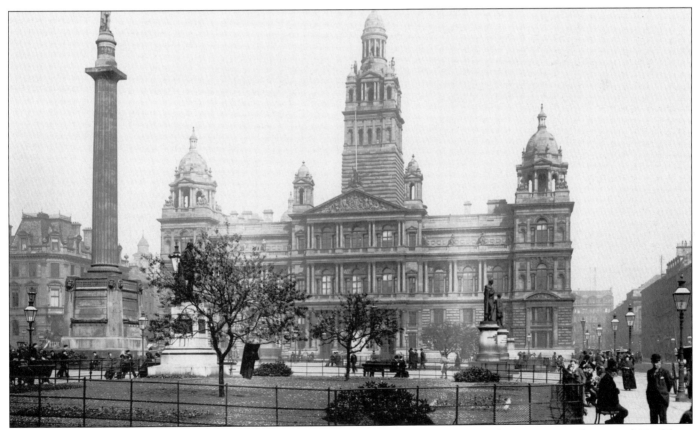

PIC39760 GEORGE SQUARE. It used to be said that George Square reminded visiting Londoners of Trafalgar Square, except that the central column was a monument to Sir Walter Scott instead of Lord Nelson. The Square served to emphasise Glasgow's self-proclaimed status as 'the second city of the Empire.' Here were the magnificent municipal buildings, completed in 1888 at a cost of £540,000, including the post office, the Bank of Scotland, the Merchant's House and several hotels.

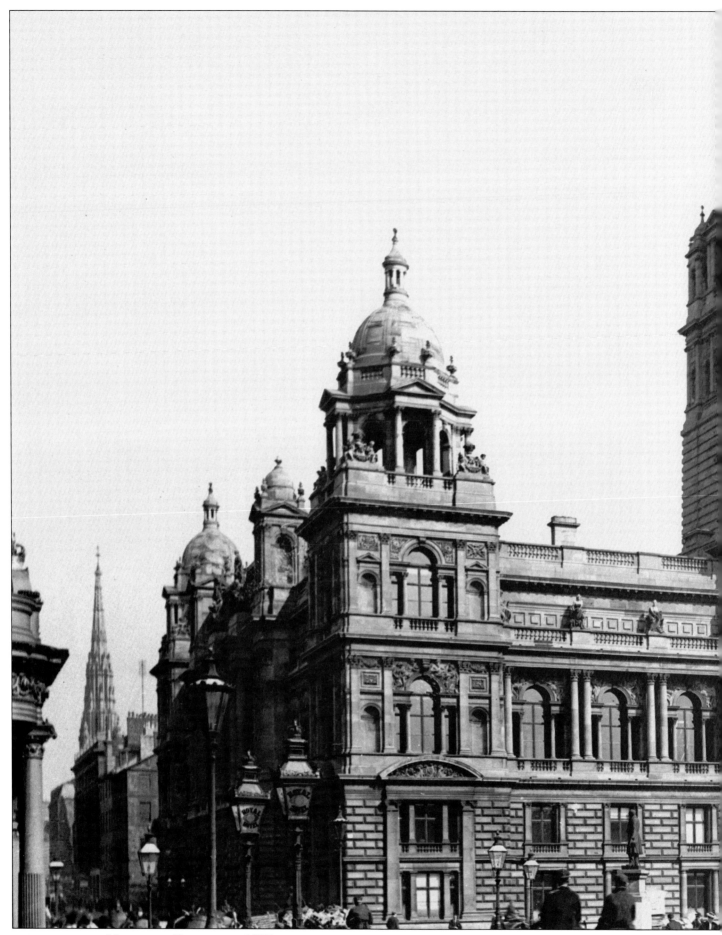

PIC39761 Municipal Buildings, 1897.

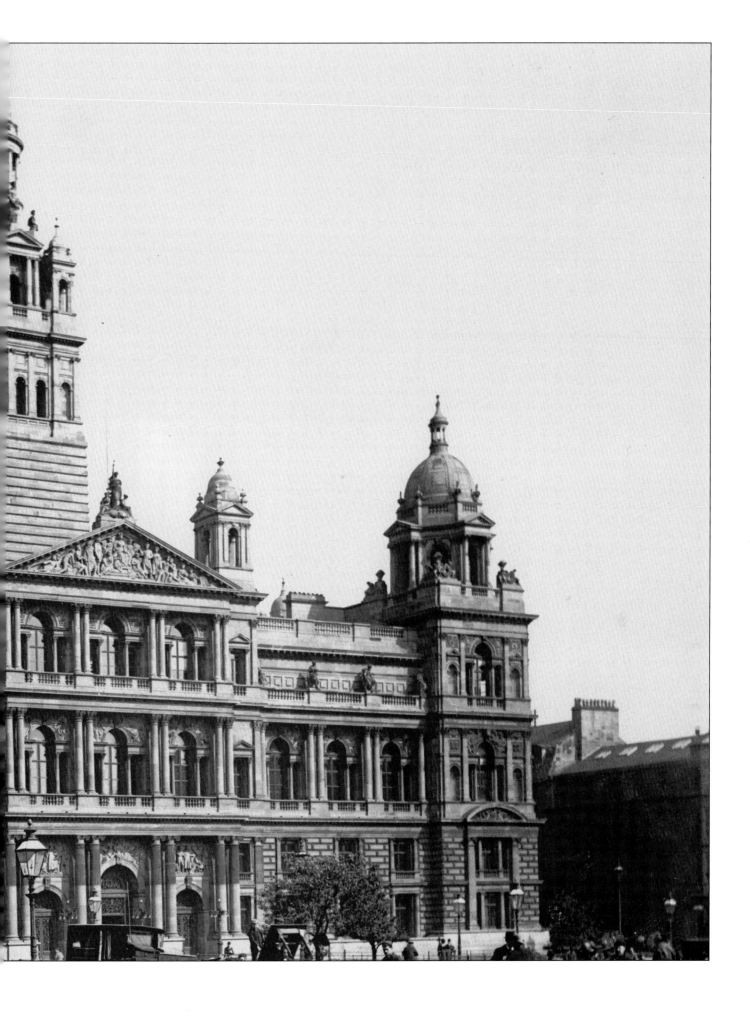

PIC39765　　　VIEW OF GLASGOW CENTRE. In late-Victorian Glasgow, Argyle Street, Buchanan Street, Union Street and Sauchihall Street were considered the places for shopping.

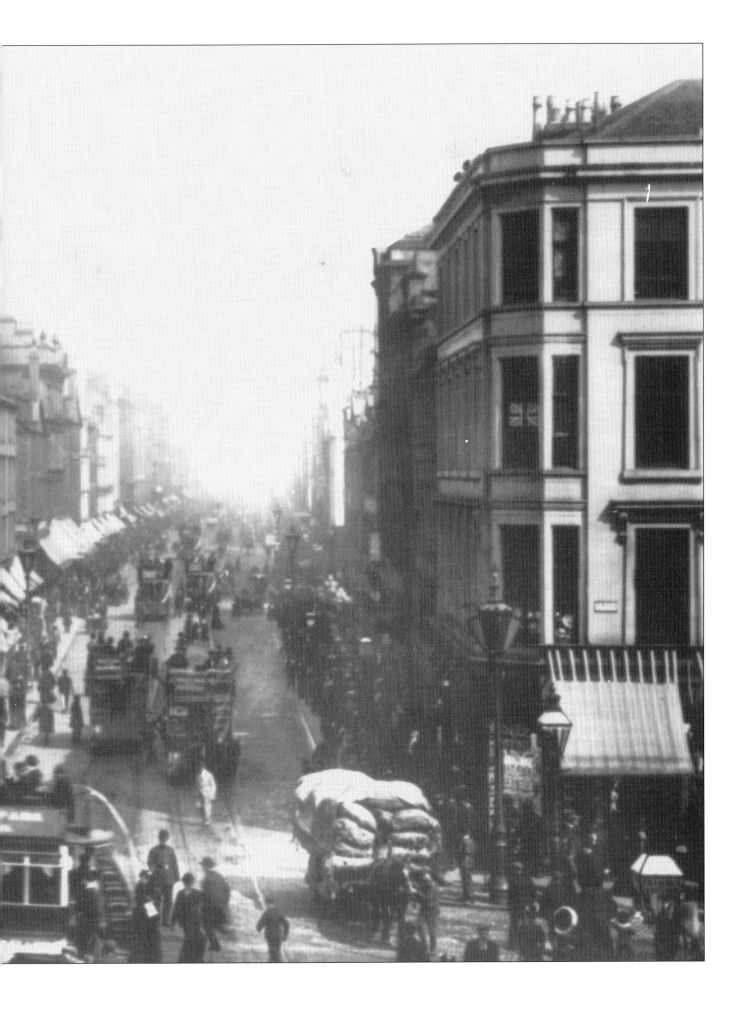

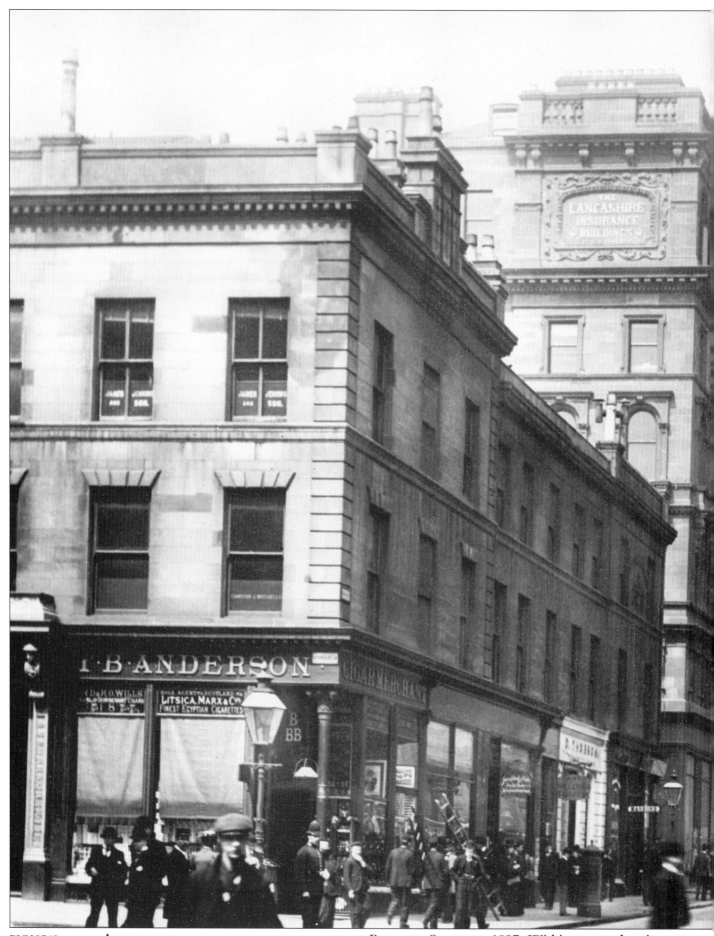

PIC39769 A CONVOY OF HORSE-TRAMS TRUNDLE ALONG RENFIELD STREET IN 1897. Within a year electric street trams would be running and the horse-trams phased out. Glasgow was the last city in the UK to abandon its tramway system. The Leeds system closed in 1959, Sheffield in 1960 and Glasgow in 1962.

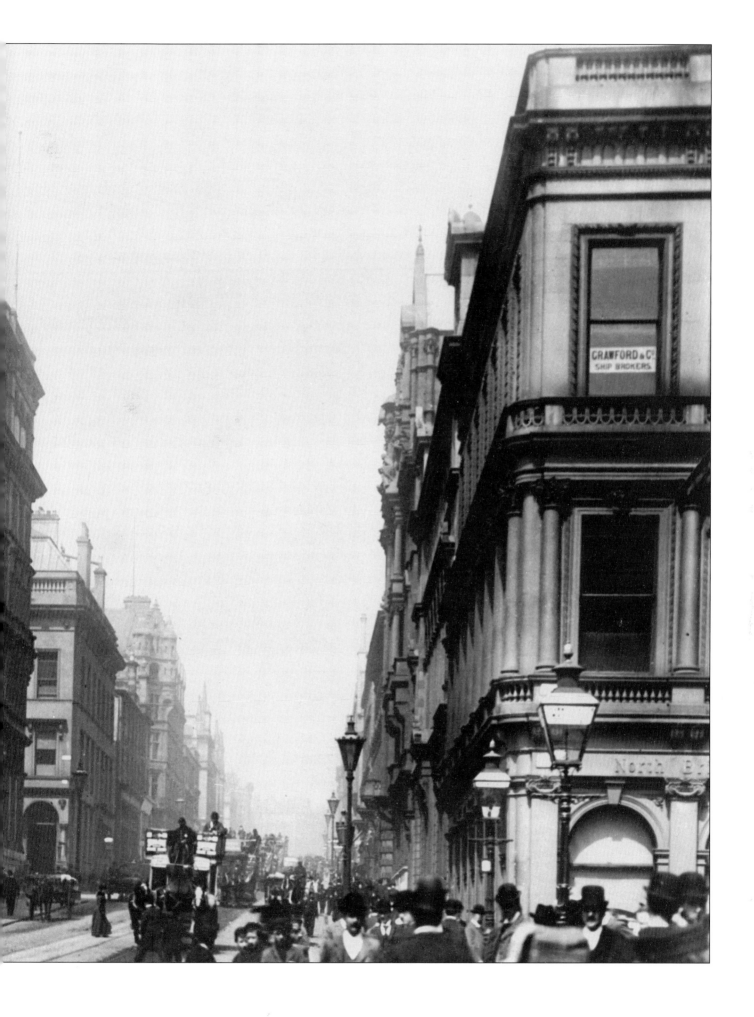

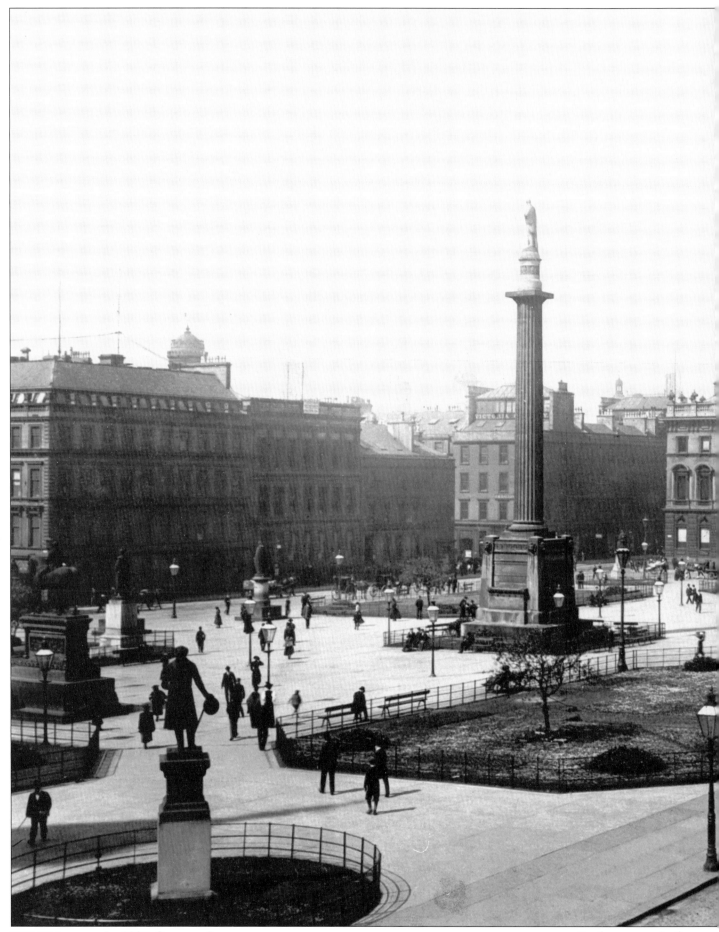

PIC39759 IN 1897 GEORGE SQUARE WAS CONSIDERED THE FINEST OPEN SPACE IN THE CITY. In the centre is the 80ft column surmounted by a statue of Sir Walter Scott. Other statues included those of Queen Victoria and Prince Albert, William Pitt, Sir Robert Peel, Robert Burns, Dr Livingstone, James Watt and Sir John Moore.

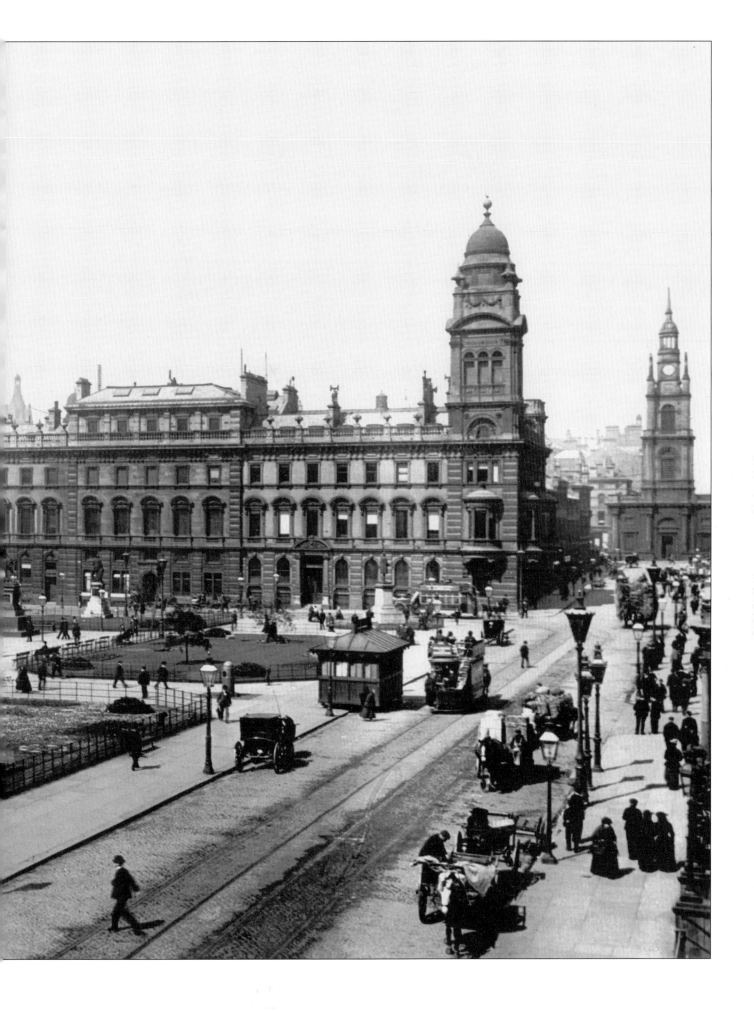

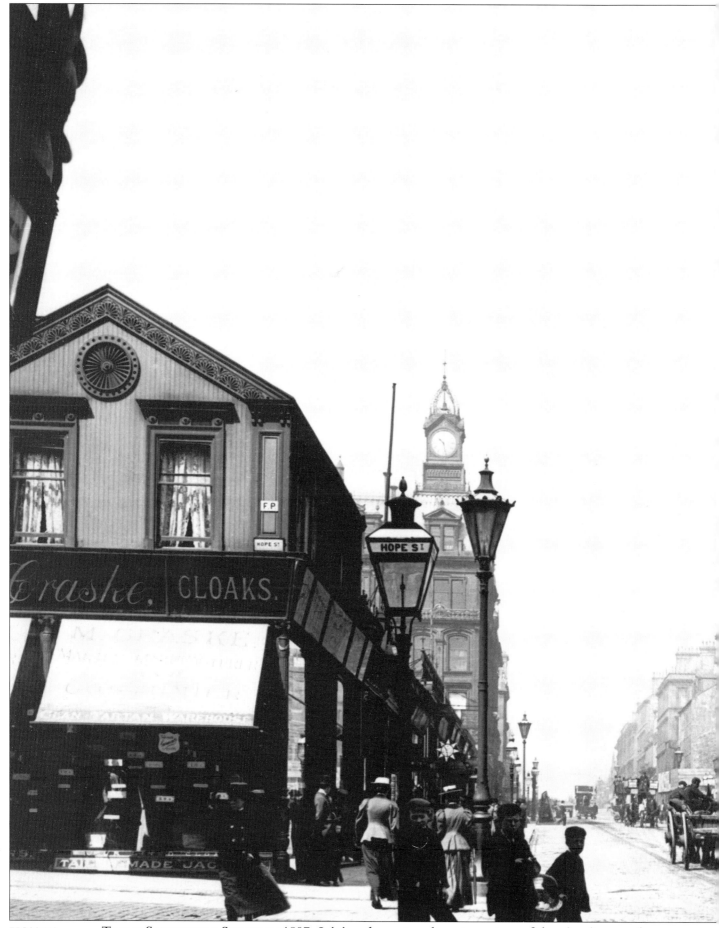

PIC39763 THIS IS SAUCHIHALL STREET IN 1897. Joining the east and west quarters of the city, it was where you could buy quality confectionery from Assafrey, dine out at the Hippodrome, attend an exhibition at the Institute of Fine Arts, or stay at a temperance hotel.

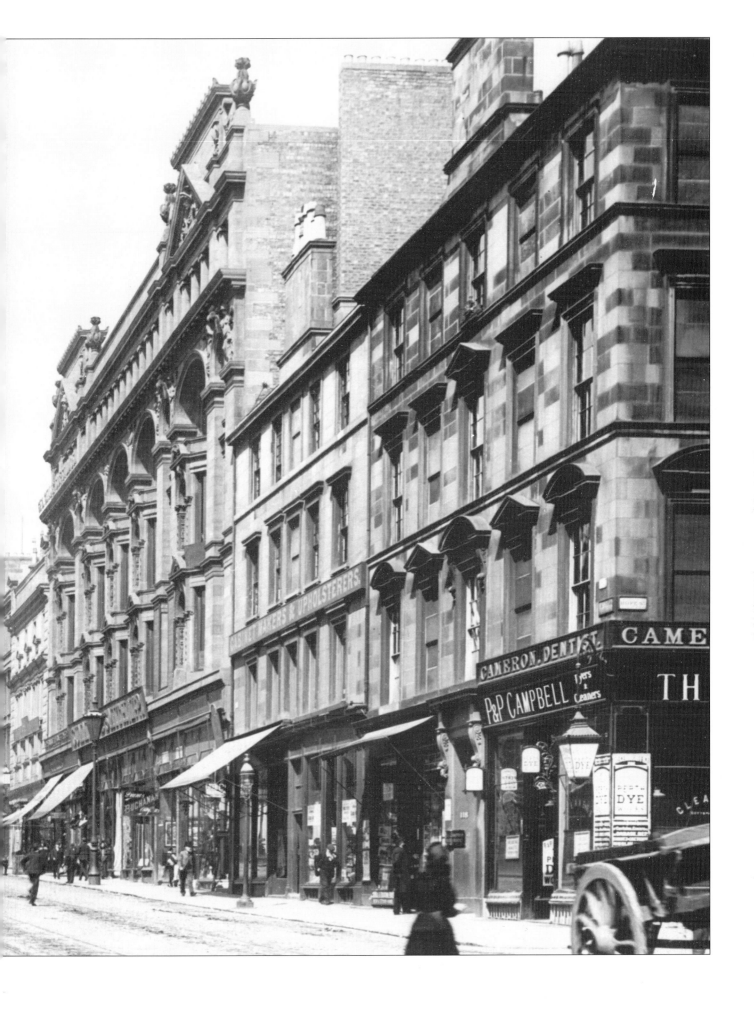

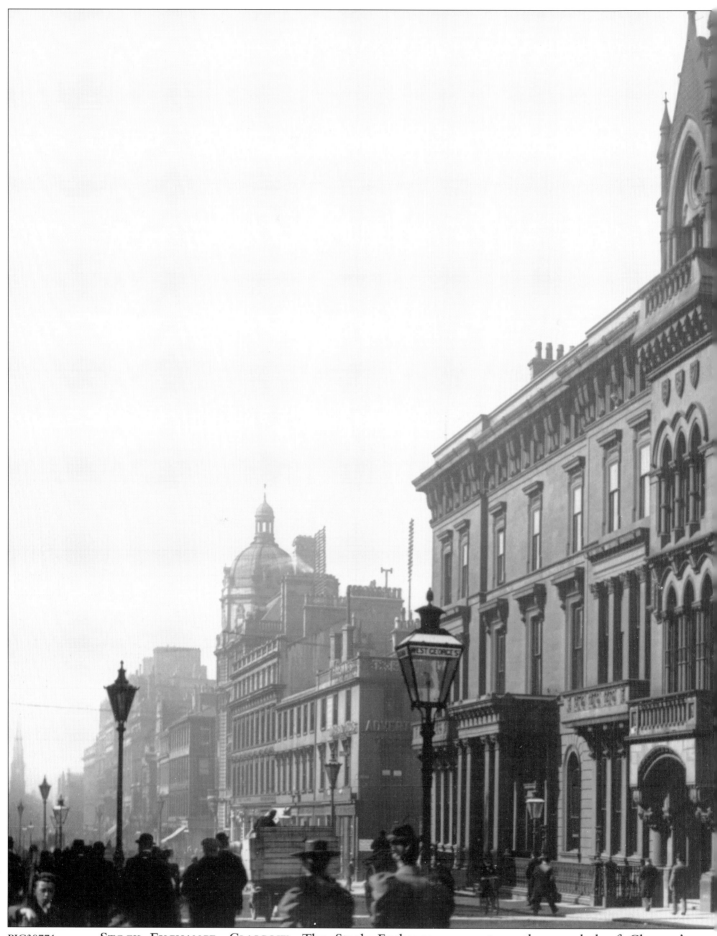

PIC39771 STOCK EXCHANGE, GLASGOW. The Stock Exchange was yet another symbol of Glasgow's industrial might.

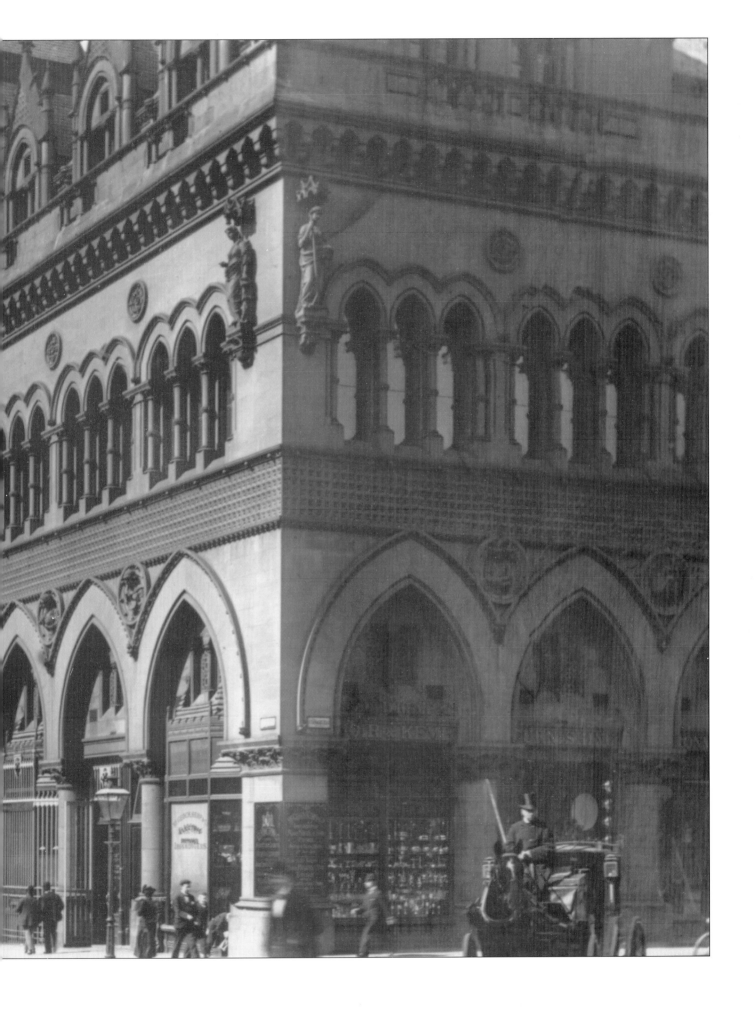

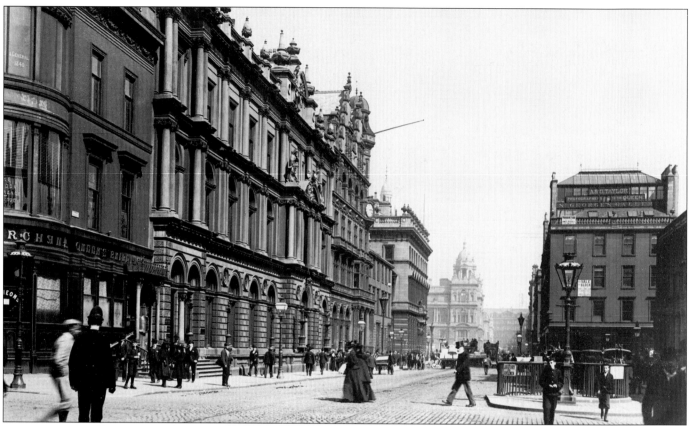

PIC39764 ST VINCENT'S PLACE LOOKING TOWARDS GEORGE SQUARE. St Vincent's Place was right in the commercial heart of the city, with the National Bank, Royal Exchange, Stock Exchange, and Athenaeum Club all nearby.

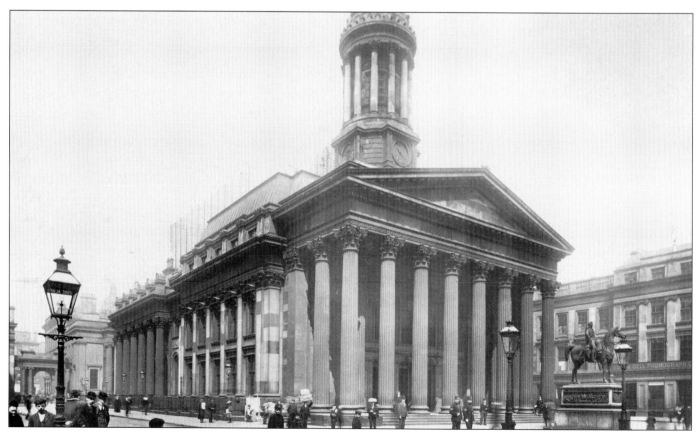

PIC39798 THE ROYAL EXCHANGE WAS BUILT IN THE CORINTHIAN STYLE. It was one of the many buildings which symbolised Glasgow's industrial and economic status. At the beginning of the nineteenth century, only one Scot in twenty lived in Glasgow. By the end of the century the figure was one in five.

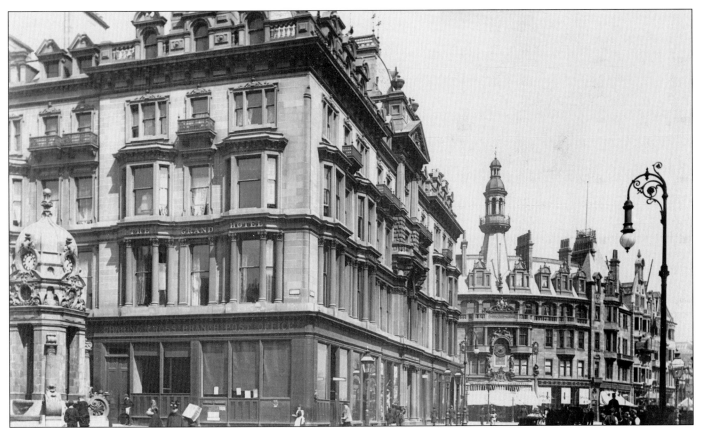

PIC39768 THE GRAND HOTEL, CHARING CROSS. The Grand Hotel at the west end of Charing Cross had rooms from 3*s* 6*d* a night with dinner costing 5s. The two most expensive hotels were the Central and the Windsor where rooms started at 4*s* 6*d* a night. Most charged around 5*s* for dinner, though the Victoria in West George Street charged just 3*s* 6*d*.

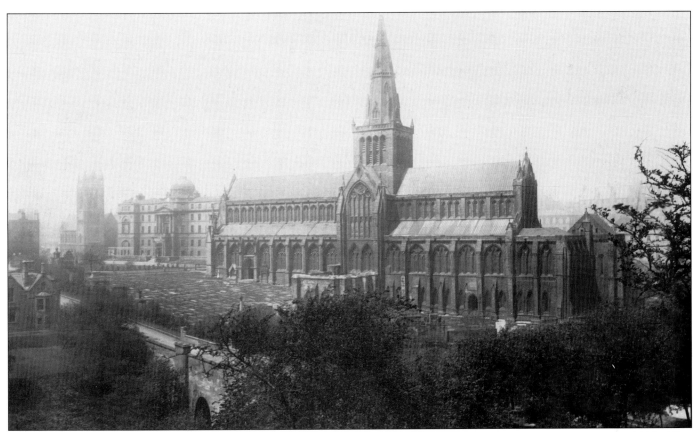

PIC39774 GLASGOW CATHEDRAL STANDS ON THE SITE OF AN EARLIER BUILDING DESTROYED BY FIRE IN 1192. The choir and tower date from the thirteenth century, the spire being added a couple of centuries later. The building is 320 ft long, 70 ft wide and 90 ft high and the tower is 220 ft high.

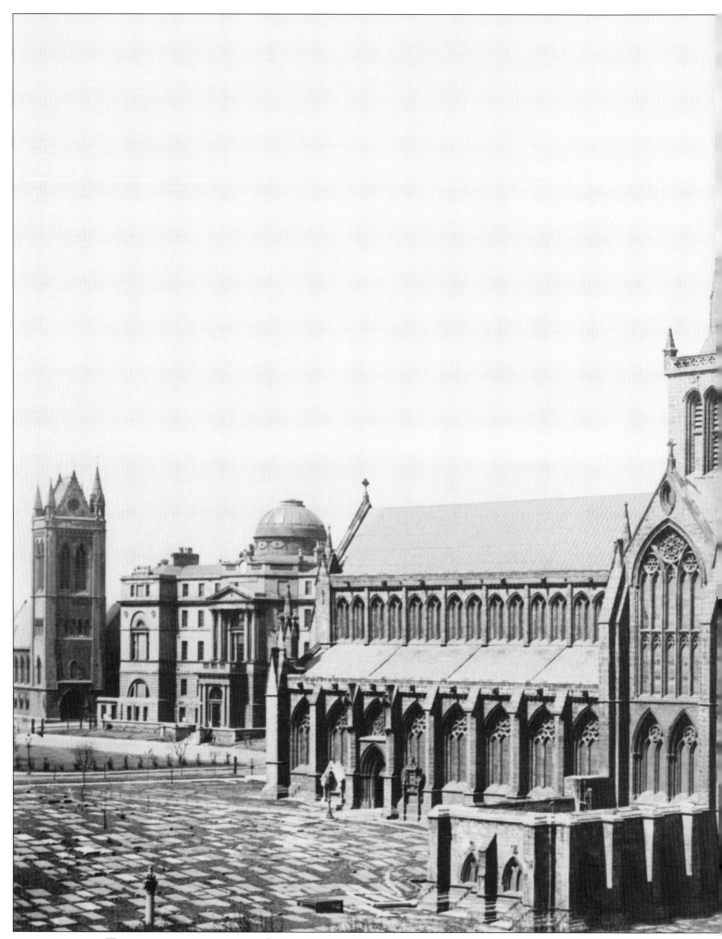

PIC39775 THIS PHOTOGRAPH OF THE CATHEDRAL IN GLASGOW WAS TAKEN IN 1897.

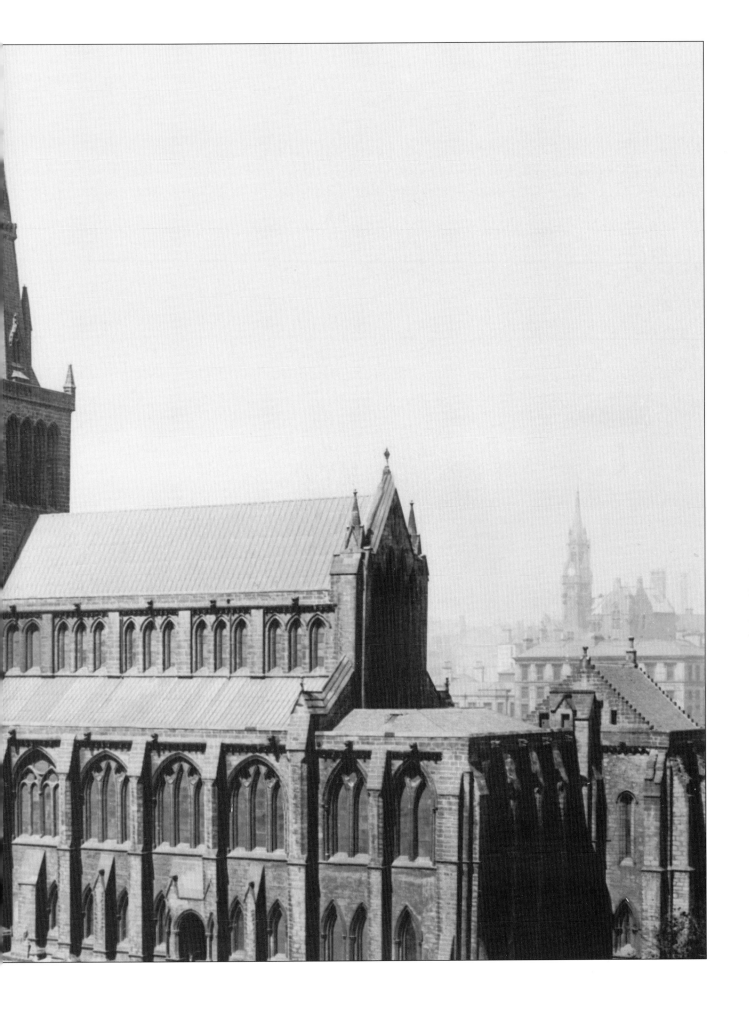

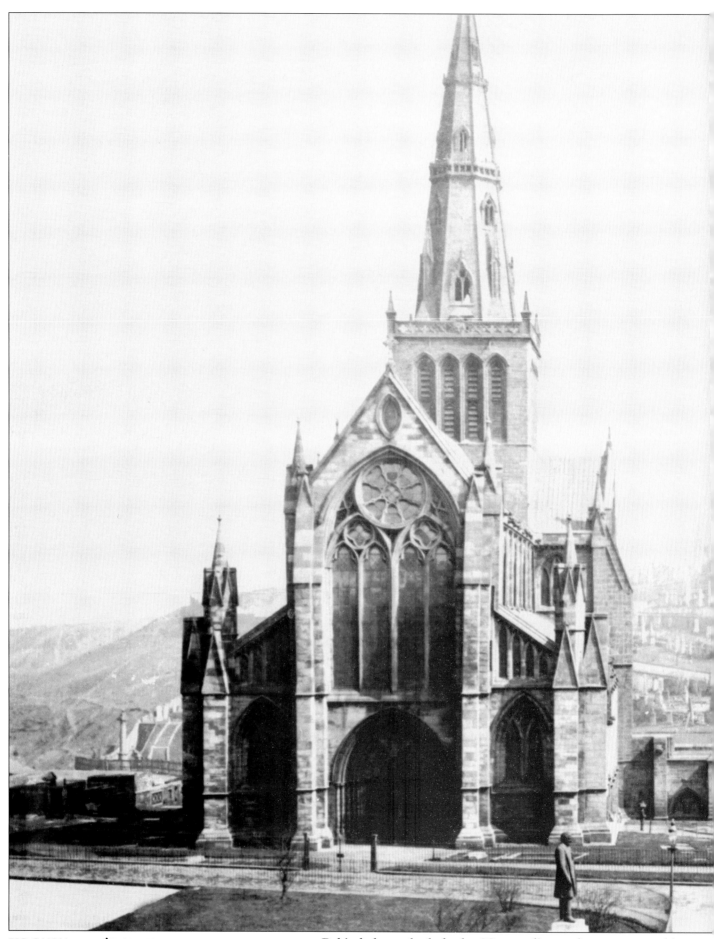

PIC G11001 ANOTHER VIEW OF THE CATHEDRAL. Behind the cathedral, the Necropolis can be seen, stretching from the left and to the right of the photograph.

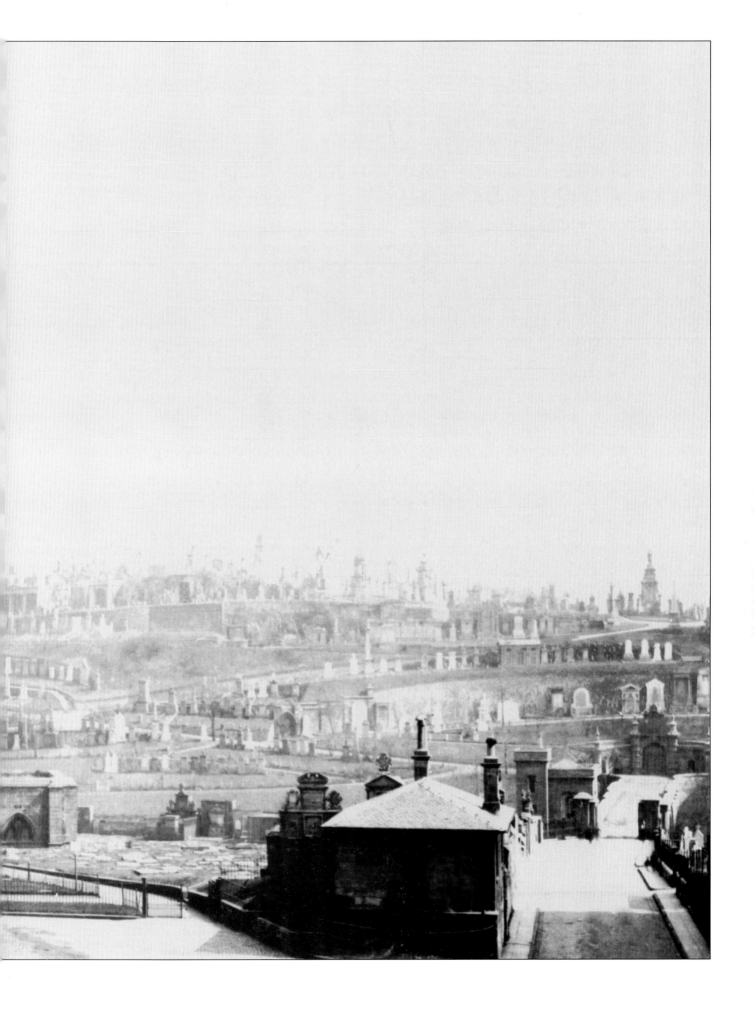

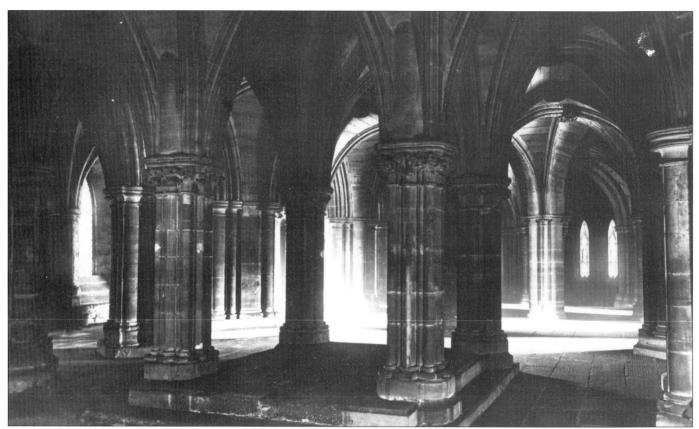

PIC39783 THE CRYPT, GLASGOW CATHEDRAL. Part of the crypt dates from 1197 when it was consecrated by Bishop Jocelin. It is well proportioned with fine pillars and vaulting. In the centre of the crypt is the site of the tomb of St Kentigern (St Mungo) and it was over his grave that the first church was erected.

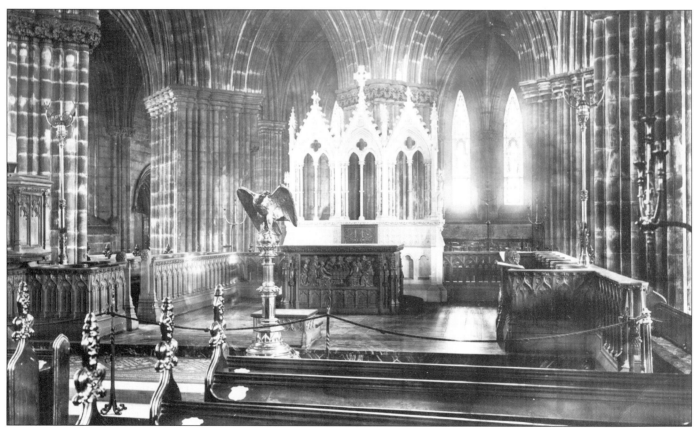

PIC39780 VIEW OF INSIDE GLASGOW CATHEDRAL. The choir dates from the thirteenth century and contains a superb fifteenth century stone screen. Behind the choir are the Chapter House, which has a richly carved doorway, and the Lady Chapel. In the Chapter House is a gravestone to the memory of nine martyred Covenanters.

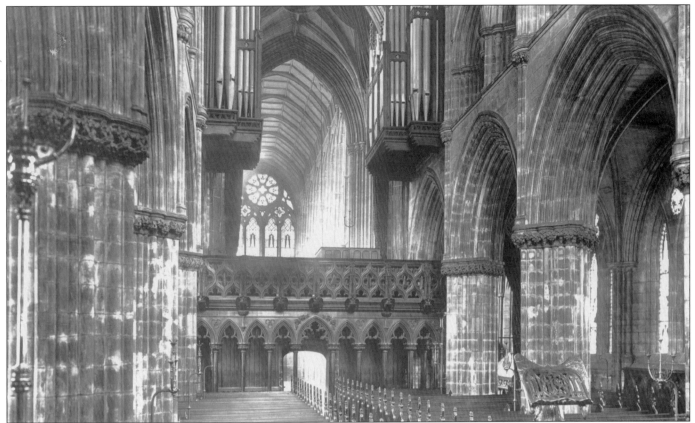

PIC39779 LOOKING WEST FROM THE CHOIR TOWARDS THE NAVE. Glasgow Cathedral survives almost intact and is said to be the most complete in Scotland, having lost only its western towers which were dismantled during the nineteenth century.

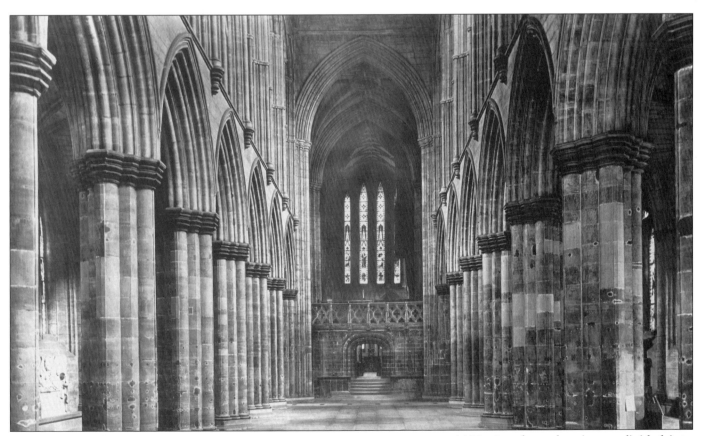

PIC39778 THE NAVE WITH ITS TIMBERED CEILING WAS COMPLETED IN 1480. At a later date it was divided into three congregations, the nave, choir and crypt. In this picture from 1897, we can see the screen separating the nave and choir. During the nineteenth century the windows throughout the church were filled with stained glass, most of it from Munich, at a cost close to £100,000.

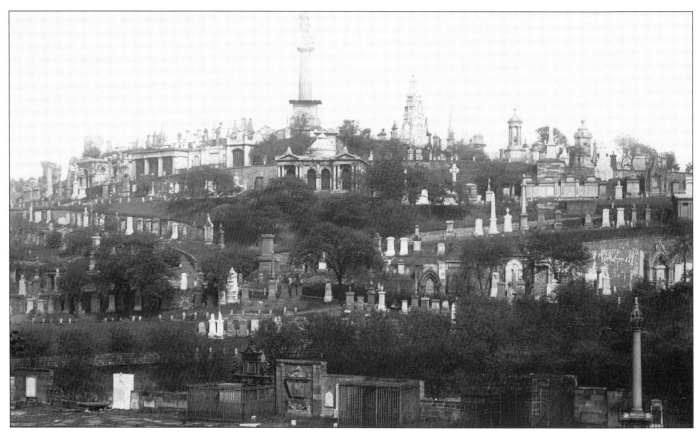

PIC39784 THE VICTORIAN CELEBRATION OF DEATH. This is the Necropolis situated behind the cathedral, containing a number of substantial monuments to the great and the good, and to those who simply had enough money to build. The large statue is to the memory of the reformer John Knox.

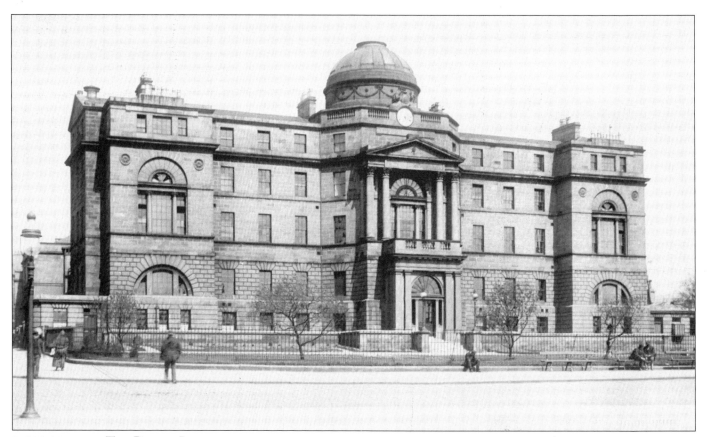

PIC39789 THE ROYAL INFIRMARY, NEXT DOOR TO THE CATHEDRAL AND JUST A HEARSE'S RIDE AWAY FROM THE NECROPOLIS. The picture dates from 1897, when nearly 430,000 people were crammed into central Glasgow, and the city's tenement blocks were a breeding ground for all manner of contagious diseases.

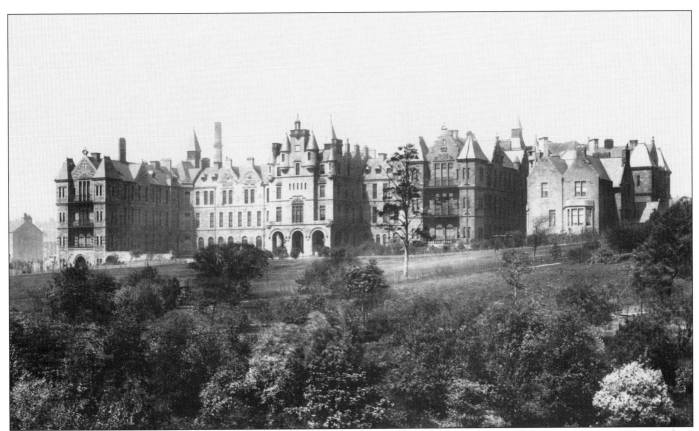

PIC39788 THE IMPOSING FRONT OF THE WESTERN INFIRMARY IN 1897. Between 1861 and 1881 the city experienced four major cholera epidemics. To add to this rickets and tuberculosis were endemic amongst mill workers and smallpox was rife. During this period, a quarter of all children born to mill workers died before reaching their first birthday.

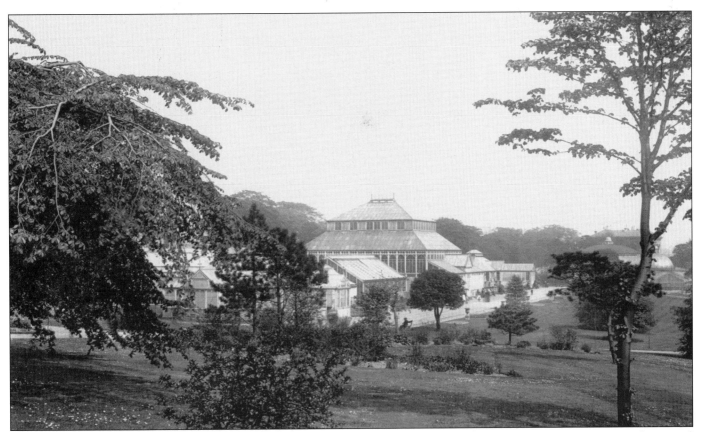

PIC39795 THE BOTANIC GARDENS OFF GREAT WESTERN ROAD. It contains many rare orchids, tree ferns and other plants, and also grows its own bananas. The Kibble Palace is the largest glasshouse in Britain.

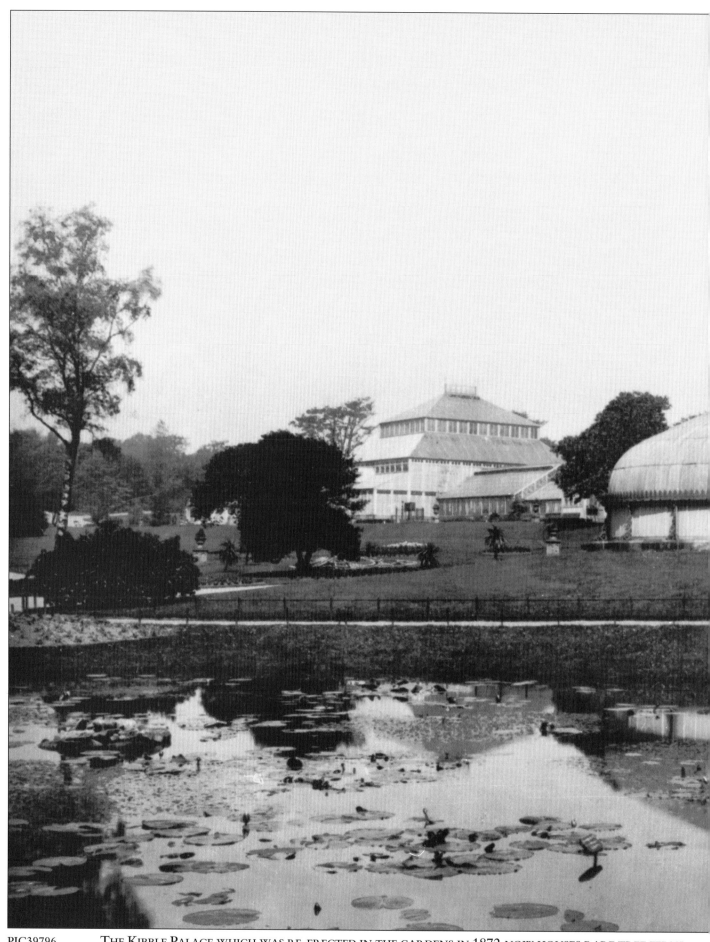

PIC39796 THE KIBBLE PALACE WHICH WAS RE-ERECTED IN THE GARDENS IN 1872 NOW HOUSES RARE TREE FERNS.
Both William Gladstone and the Earl of Beaconsfield used the building to deliver their rectorial addresses to members of the university.

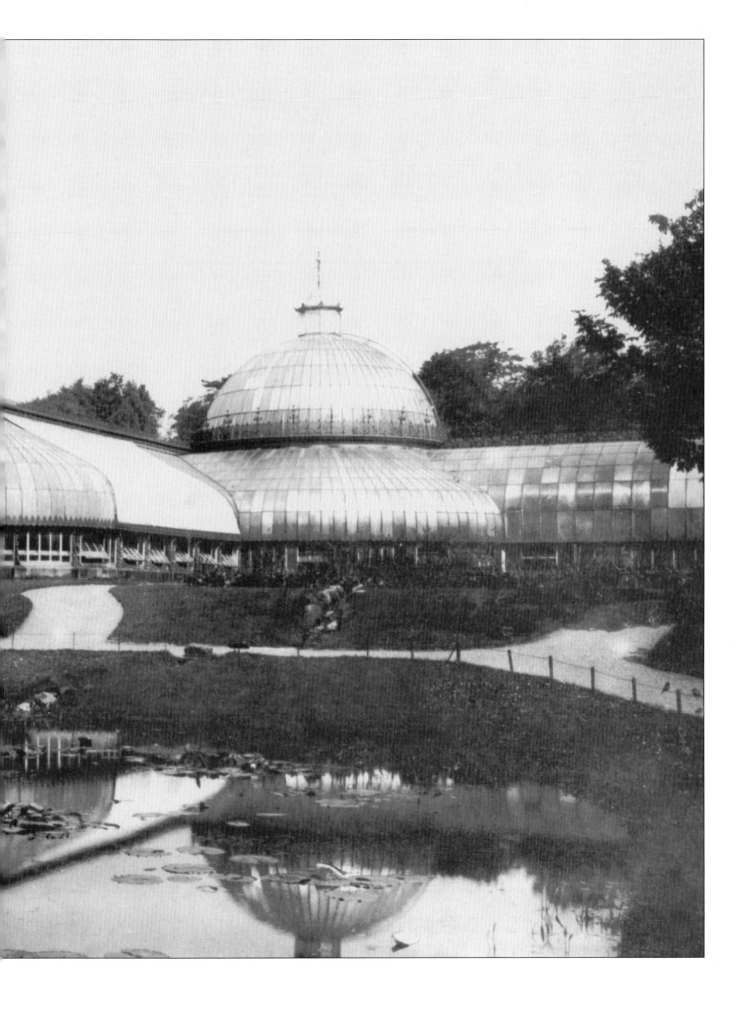

PIC39757 KELVINGROVE PARK IN 1897, THE CENTRAL FEATURE OF WHICH WAS THE STEWART MEMORIAL FOUNTAIN. The park was chosen as the site for a museum and art gallery, which opened in 1901. For decades the art gallery contained the finest municipal collection of Dutch, French and Scottish schools in Britain.

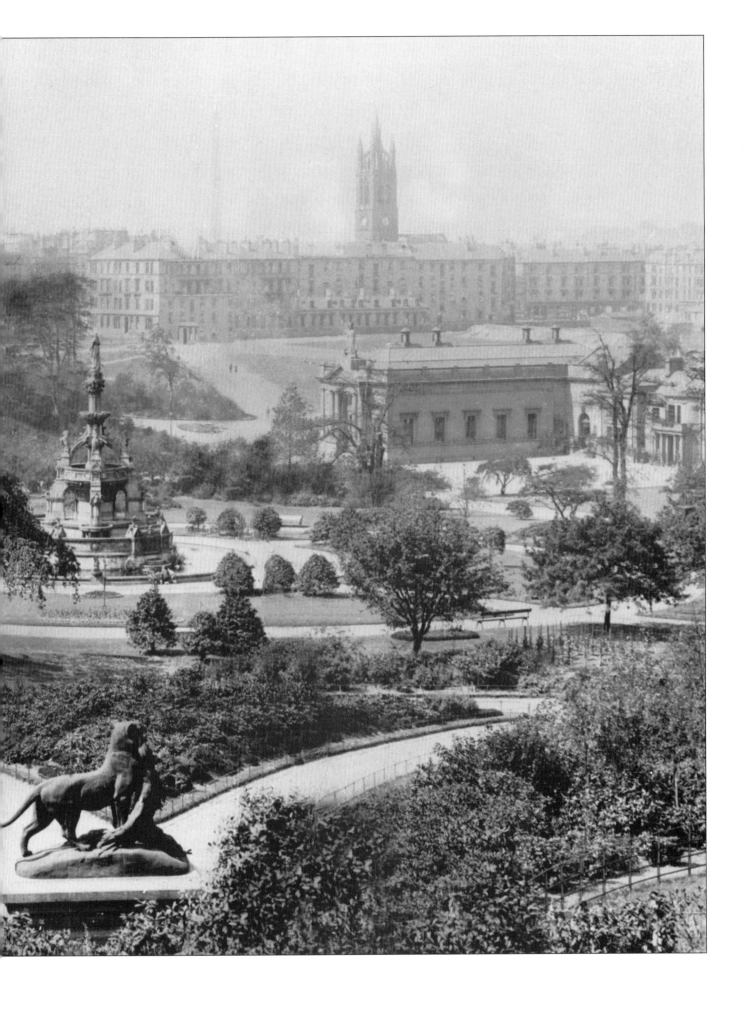

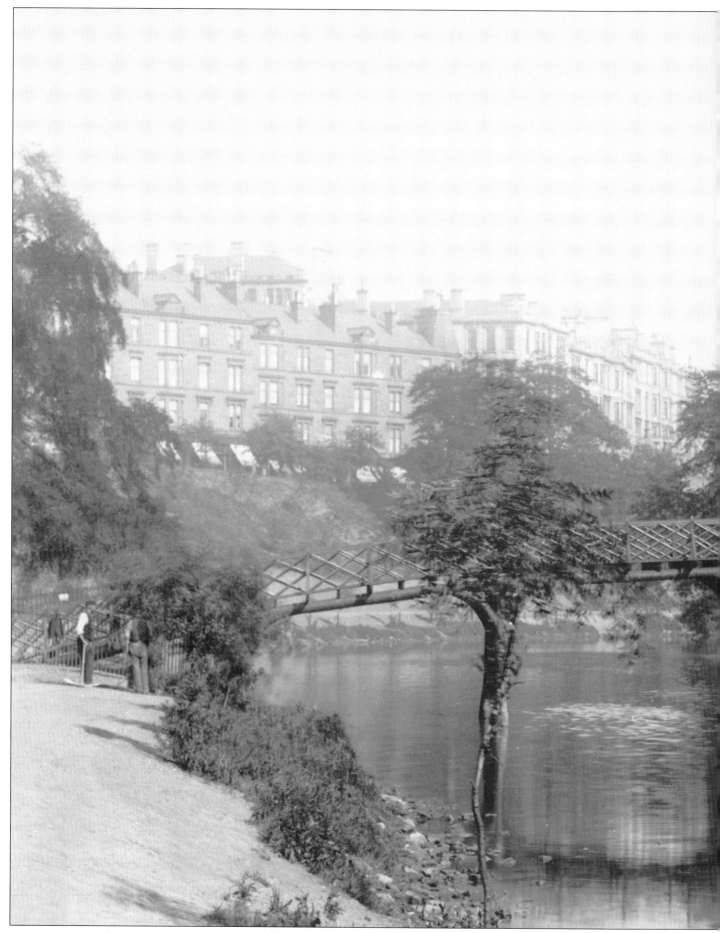

PIC39758 A VIEW ON THE KELVIN IN 1897. Covering 85 acres, Kelvingrove Park was the venue for a number of international exhibitions, but was eventually considered too small. The 1938 Empire Exhibition was staged at Bellahouston Park at a staggering cost of £11,000,000 and attracted over 13,500,000 visitors.

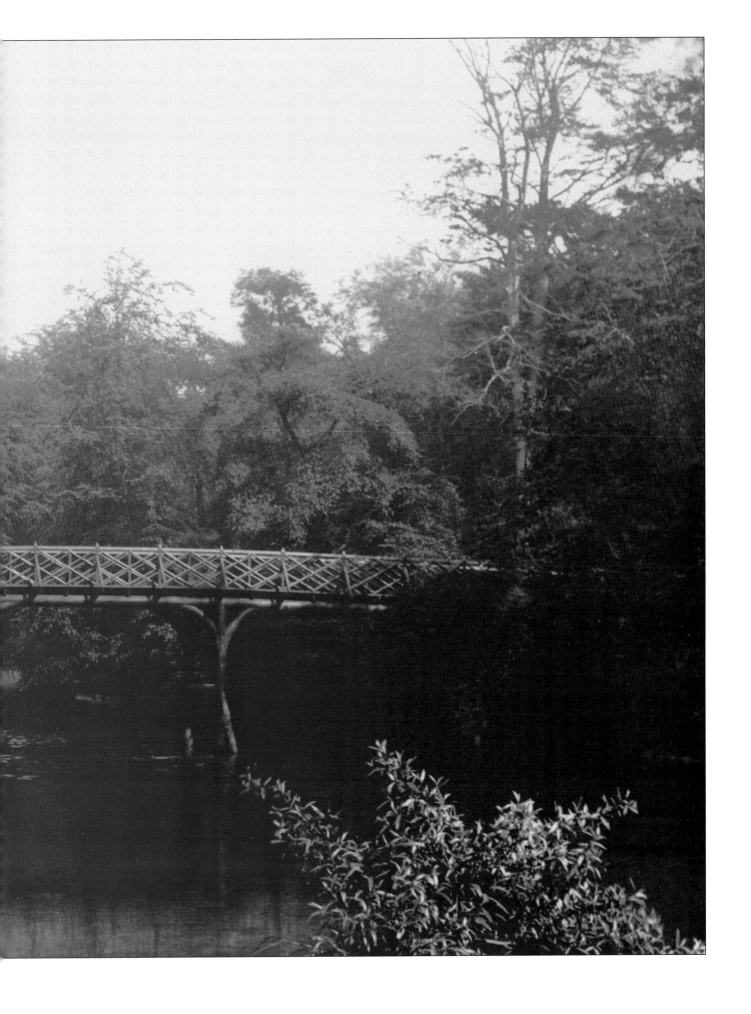

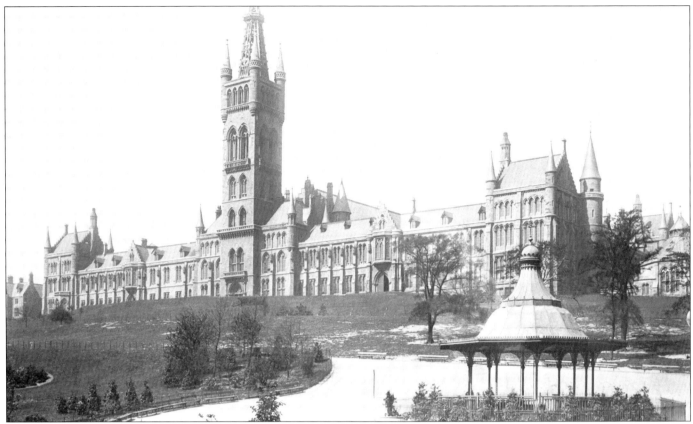

PIC39785 THE UNIVERSITY WAS FOUNDED IN 1450, MOVING TO THE GILMOREHILL SITE IN 1870. Designed by Sir Gilbert Scott, the university building is dominated by its 200 ft tower topped off with a 100 ft spire.

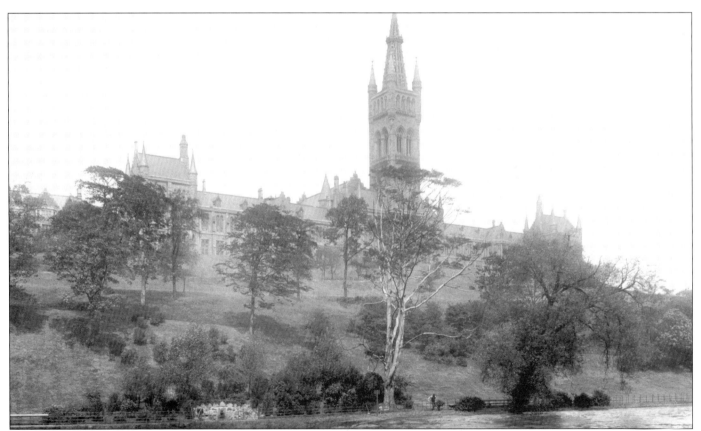

PIC39787 GLASGOW UNIVERSITY. In the sixteenth century one of Glasgow University's leading academics was Andrew Melville. Melville had studied in France and taught at Calvin's academy in Geneva. It was he who brought Scotland's university teaching methods into line with Geneva, forming the basis of academic life for over three centuries.

PAISLEY

By 1900 Paisley was an overcrowded, smoky, industrial town with a population approaching 80,000. Though spinning and weaving were the main employers there were several shipyards along the banks of the River Cart. The longest-lived was Fleming & Ferguson who specialised in building dredgers, hoppers and lighters. There was also the Thistle shipyard of Bow McLachlan who had a reputation for building tugboats. The Thistle yard closed in the 1930s but was reopened during the Second World War for the construction of landing craft.

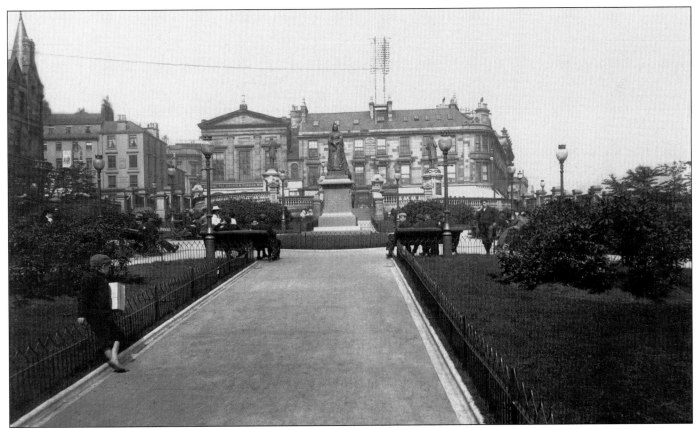

PIC47398 DUNN SQUARE IN 1901. Paisley was the last stronghold of the highly skilled craft of fine hand-loom weaving, and as late as 1834 there were few if any power looms in the town. The Paisley weavers were specialists, producing goods for a luxury market. The end came not so much from power looms, but more from printed imitations. One interesting fact about power looms is that the motive power could be eccentric. In one Glasgow mill they used a treadmill worked by a large and possibly manic Newfoundland dog.

PIC45993 THE RAIN APPEARS TO HAVE STOPPED FOR THE MOMENT IN THIS PICTURE OF PAISLEY HIGH STREET TAKEN IN 1900. Note the different styles of streetlights, there are at least three on the right hand side, whilst on the left the remains of gaslights are very much in evidence.

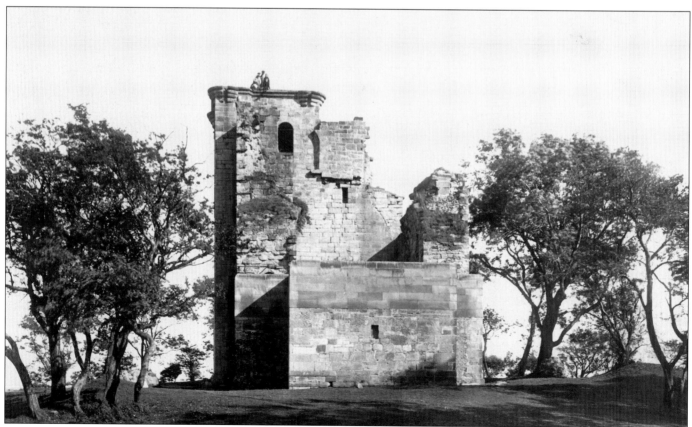

PIC39808 CROOKSTON CASTLE, PAISLEY. It was to here that Mary Queen of Scots and Henry, Lord Darnley came following their marriage in July 1565. The castle was owned by Henry's father, the Earl of Lennox. This was the first property to be acquired by the National Trust for Scotland.

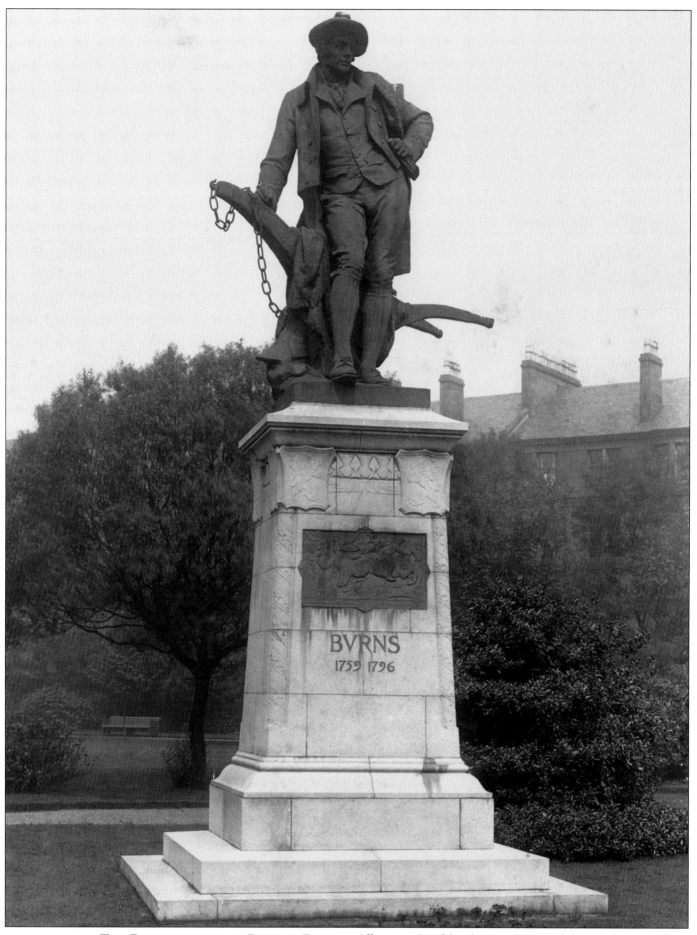

PIC45996 THE BURNS MEMORIAL, PAISLEY. Born at Alloway, Ayrshire in 1759, Burns' love of poetry was instilled in him by his teacher, John Murdoch. Burns died of rheumatic fever in 1796, contracting it after falling asleep by the roadside on his way home from a heavy drinking session.

GREENOCK

It was in the seventeenth century that Greenock developed as a port, providing a packet service to and from Ireland. During the early years of the eighteenth century facilities were improved with the construction of a harbour and quays. By 1760 the first shipyards at Greenock were open and in 1786 a graving dock had been completed. One of the most famous yards was that of John Scott, who built the first steamer to trade between Glasgow and Liverpool. Scott also built the for the Peninsular Steam Navigation Co., better known as P&O and the first three steamers for Alfred Holt's Blue Funnel Line. The East India Harbour was completed in 1806-07; the 1850s seeing the Victoria Dock opened, followed in the 1860s by the Albert Dock. A new graving dock was completed in the early 1870s and work on the James Watt Dock began in 1881.

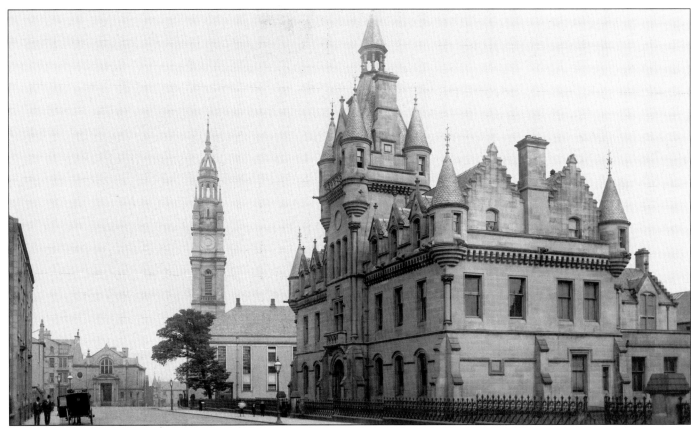

PIC39818 THE COURTHOUSE, GREENOCK IN 1897. A busy place at times, considering that imprisonment for being drunk and incapable were running at 300 a month in Glasgow alone. Between 1872-4 there were around 125,000 arrests on drink charges throughout Scotland. In 1900 Provost Black of Greenock, a strict temperance man, wanted legislation introduced to close ice-cream shops on a Sunday. Black considered that people enjoying themselves by eating ice-cream were not behaving in a proper manner on the Sabbath.

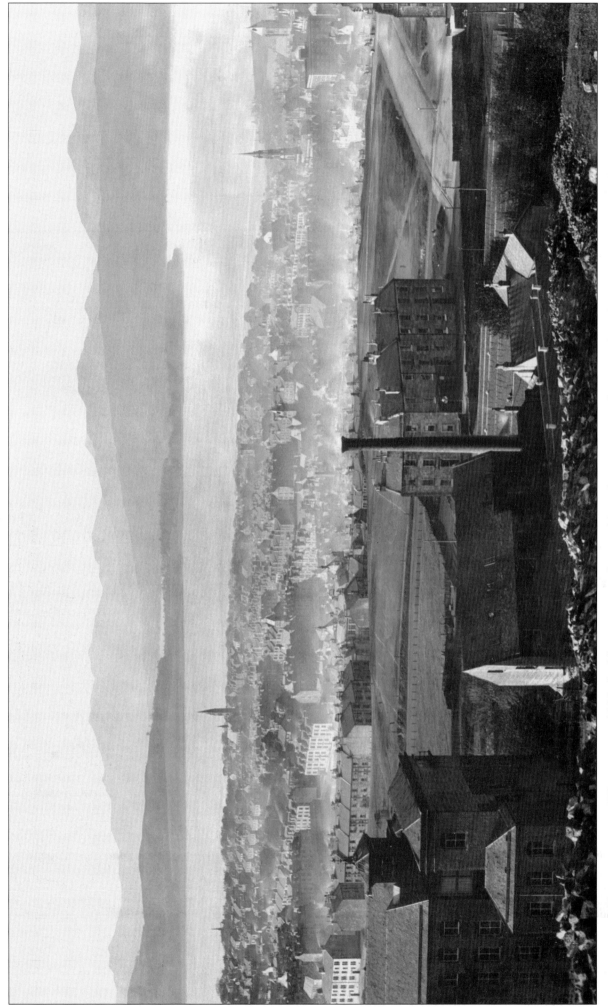

PIC43400 THE VIEW FROM WHINHILL IN 1899, looking out over the smoking chimney pots of Greenock and across the Firth of Clyde to the entrance to Gare Loch.

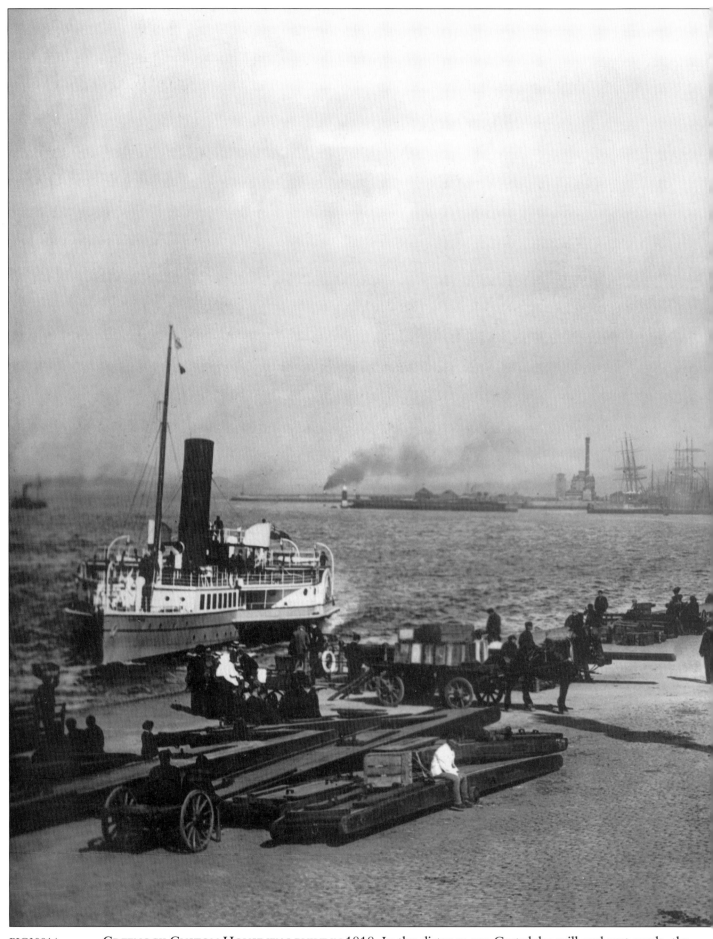

PIC39814 GREENOCK CUSTOM HOUSE WAS BUILT IN 1818. In the distance are Cartsdyke mill and east yards, the Gravel graving dock and the entrance to the James Watt Dock.

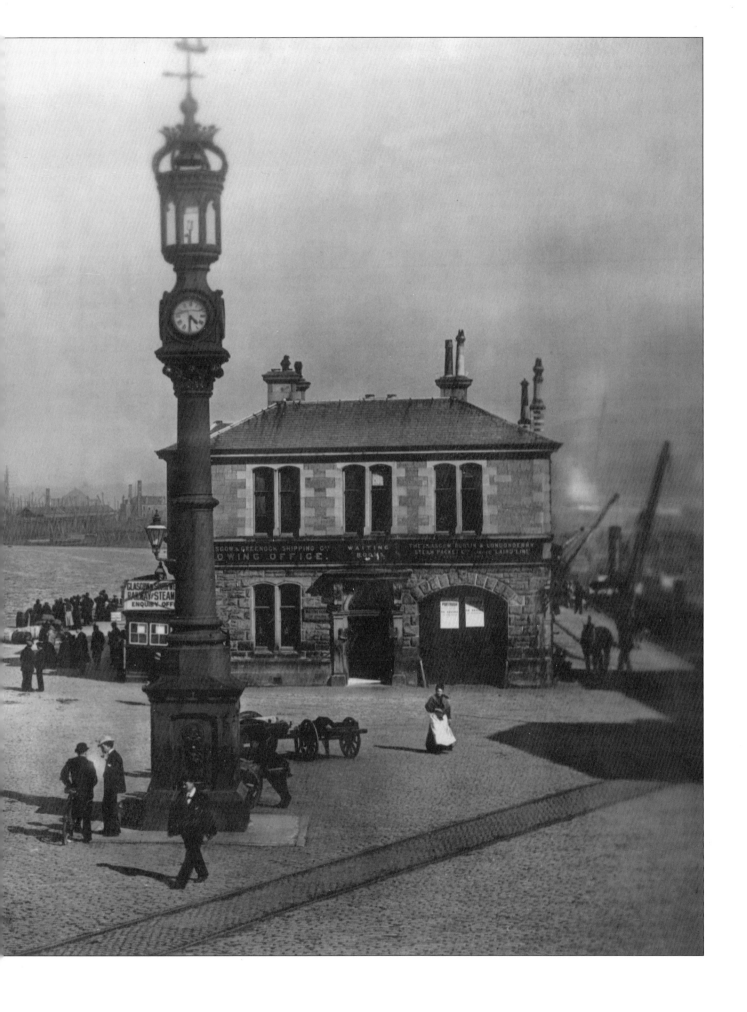

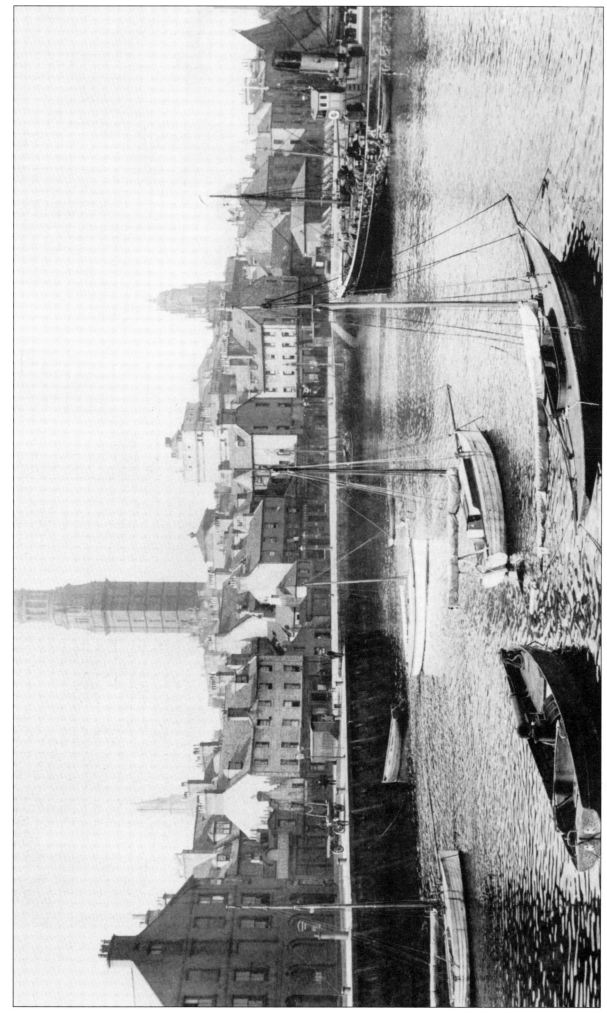

PIC52632 GREENOCK HARBOUR IN 1904. During the late seventeenth century Greenock's trade in herrings with France and the Baltic required a fleet of over 300 boats. The town motto was "Let herring swim that trade maintain". The herring went elsewhere and the trade declined.

GOUROCK

Once a few buildings huddled round a castle. It was from Gourock in 1494 that the energetic James IV sailed on his expedition of the Western Isles. Gourock was one of the towns where witch hunts took place during the seventeenth century. One of the unfortunates who was burnt at the stake, was a teenager by the name of Mary Lamont. The girl confessed (probably under torture), that she intended to throw Granny Kempock's Stone into the sea so that ships might be wrecked upon it. The stone, a pre-historic monolith of grey schist standing 6 ft high.

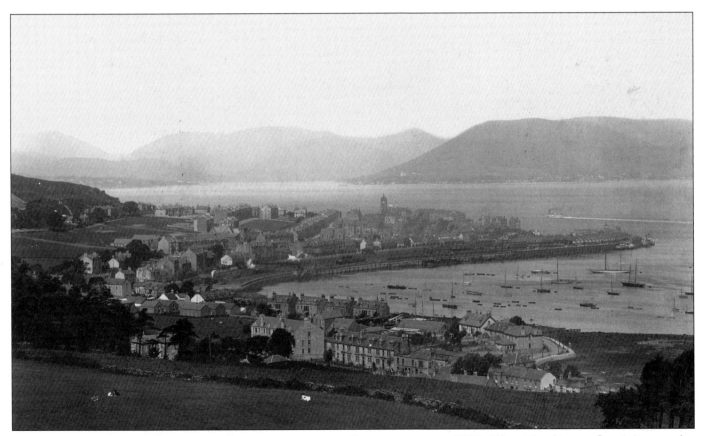

PIC45962 THIS IS A VIEW OF GOUROCK AND THE CLYDE TAKEN IN 1900. There is plenty of activity on the railway and at the pier. In the distance is Kilcreggan on the Rosneath peninsula, and the entrance to Loch Long which is backed by the Cowal hills.

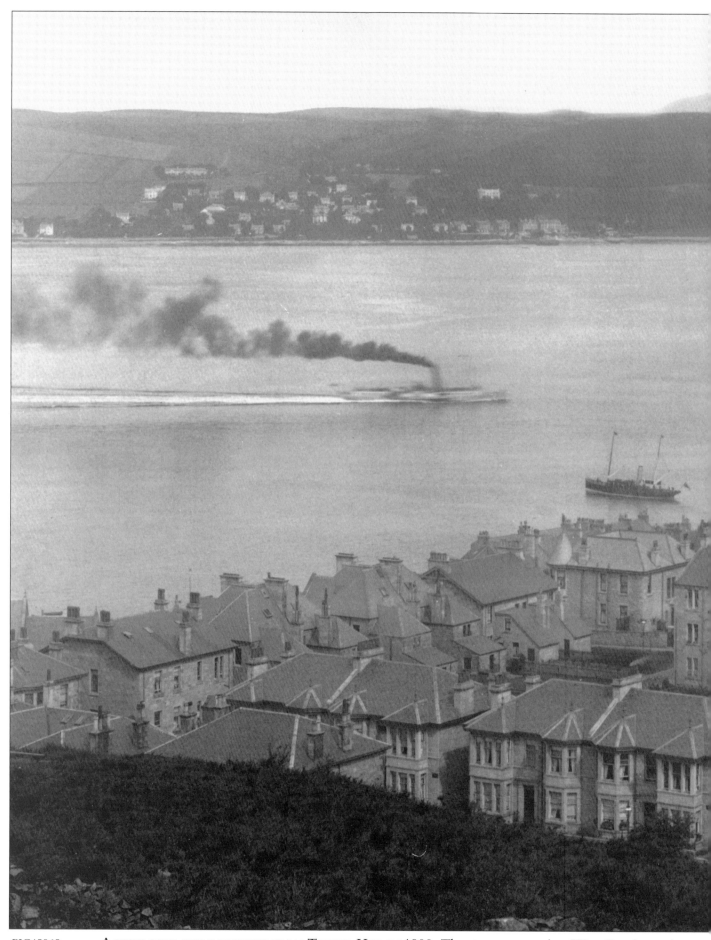

PIC45965 A VIEW OVER THE ROOFTOPS FROM TOWER HILL IN 1900. The steamer crossing West Bay is turning to berth at the pier. A steamer has just departed possibly heading for Glasgow.

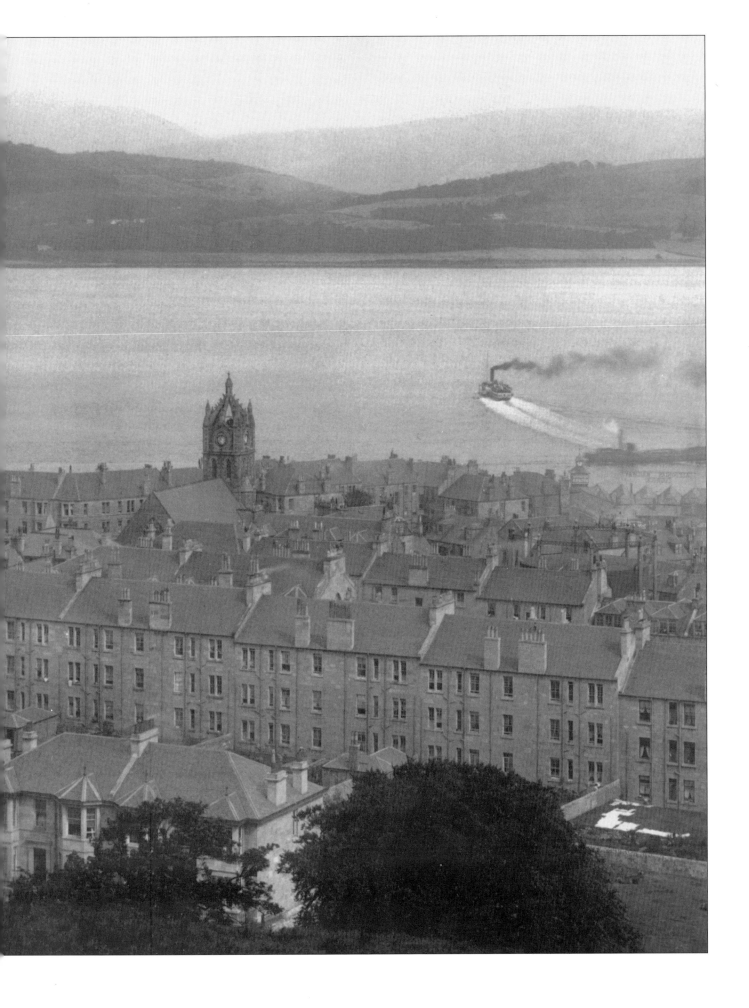

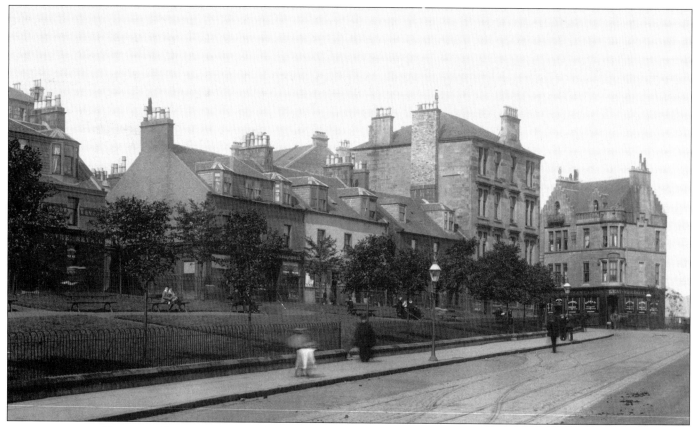

PIC45977 KEMPOCK PLACE IN 1900. The entrance to the pier for the Dunoon boats is to the right.

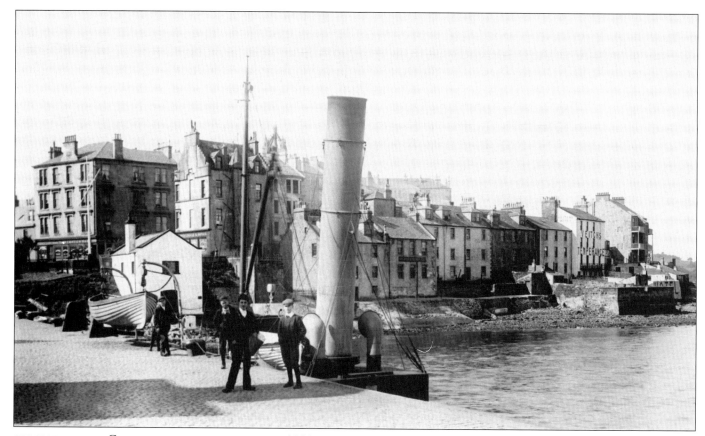

PIC45975 GOUROCK FROM THE PIER IN 1900, SHOWING THE BACKS OF BUILDINGS ALONG KEMPOCK STREET. Kempock Place is just in view on the extreme left of the picture. Over to the right is Seaton's Temperance Hotel, one of several in the town. At this time temperance hotels abounded throughout the UK, but there was in fact little difference between them and private hotels, as neither had liquor licences.

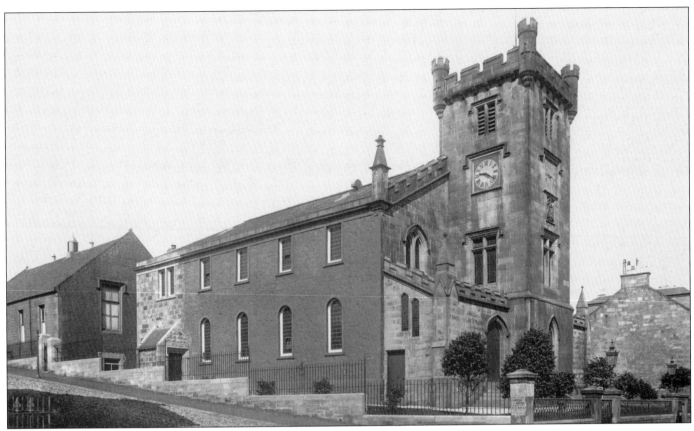

PIC45982 THE OLD PARISH CHURCH IN 1900.

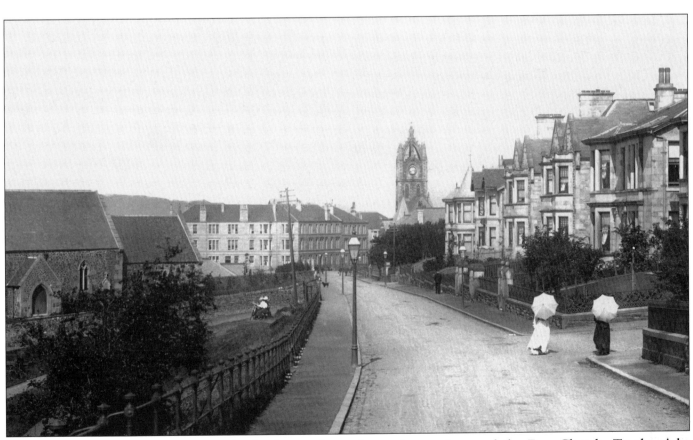

PIC45979 BARRHILL ROAD. In the background are the castle mansions and the Free Church. To the right behind the houses is Tower Hill, the site of Gourock Castle. Built in 1747 the castle was demolished before the Great War.

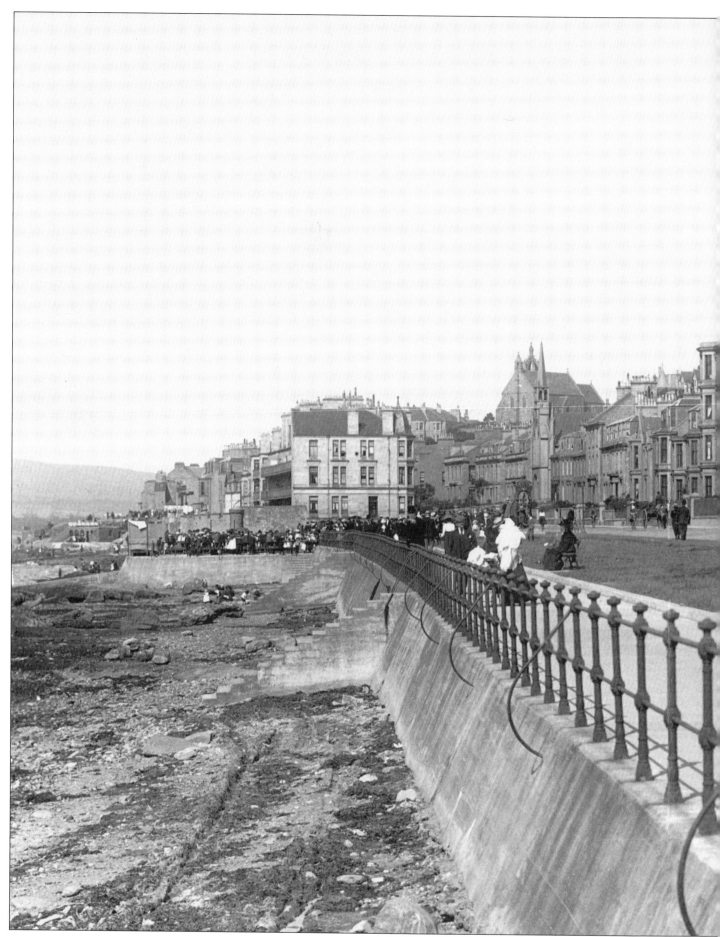

PIC45969 THE ESPLANADE IN 1900 WITH THE PEBBLE BEACH IN EVIDENCE. As well as being a resort, Gourock was noted for its herring curing. In 1688 the first recorded curing of red herrings took place here.

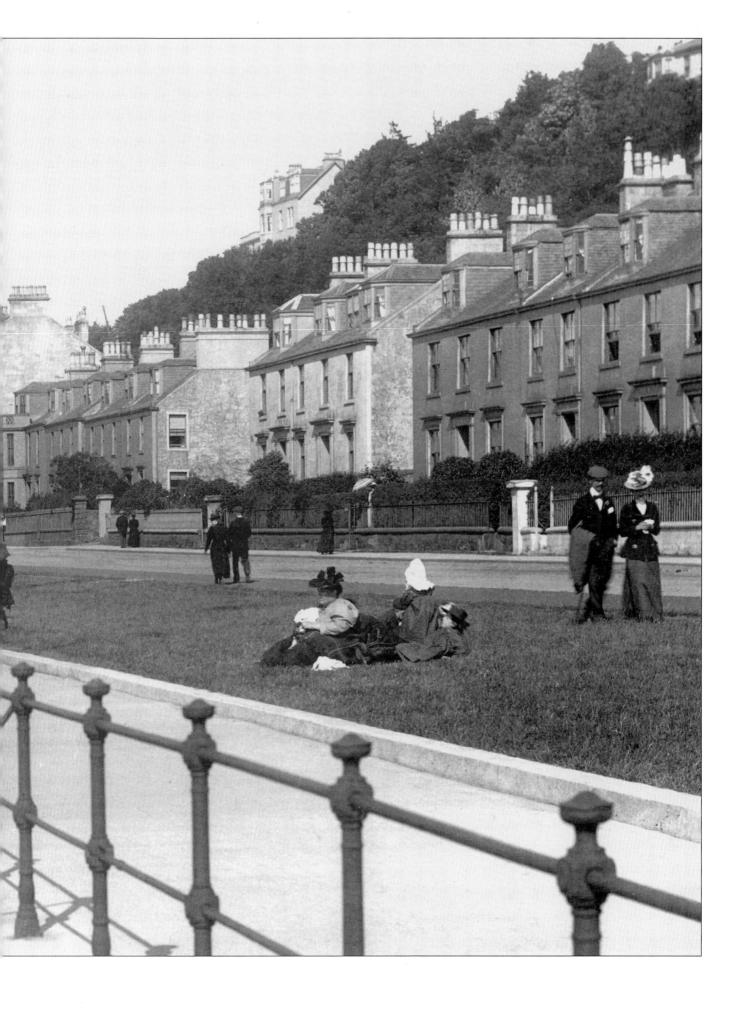

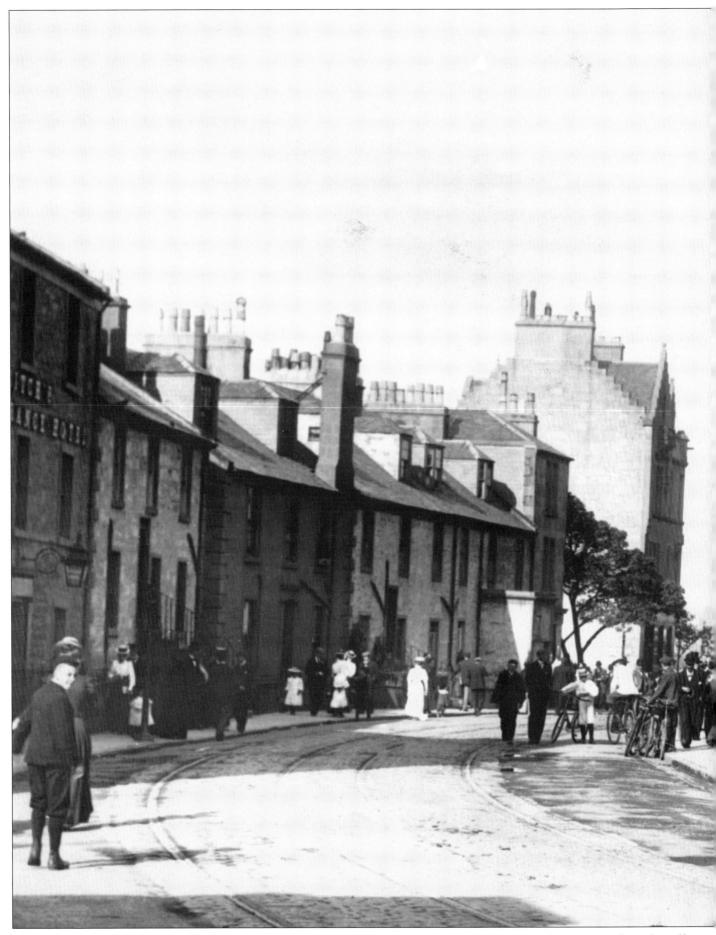

PIC45978 KEMPOCK STREET, BETWEEN ALBERT ROAD AND SHORE STREET. The total absence of road traffic other than bicycles, and that people appear to be in their best clothes, suggests that the picture was taken on a Sunday. Note the blinds on the shop windows and the attraction they hold for small boys.

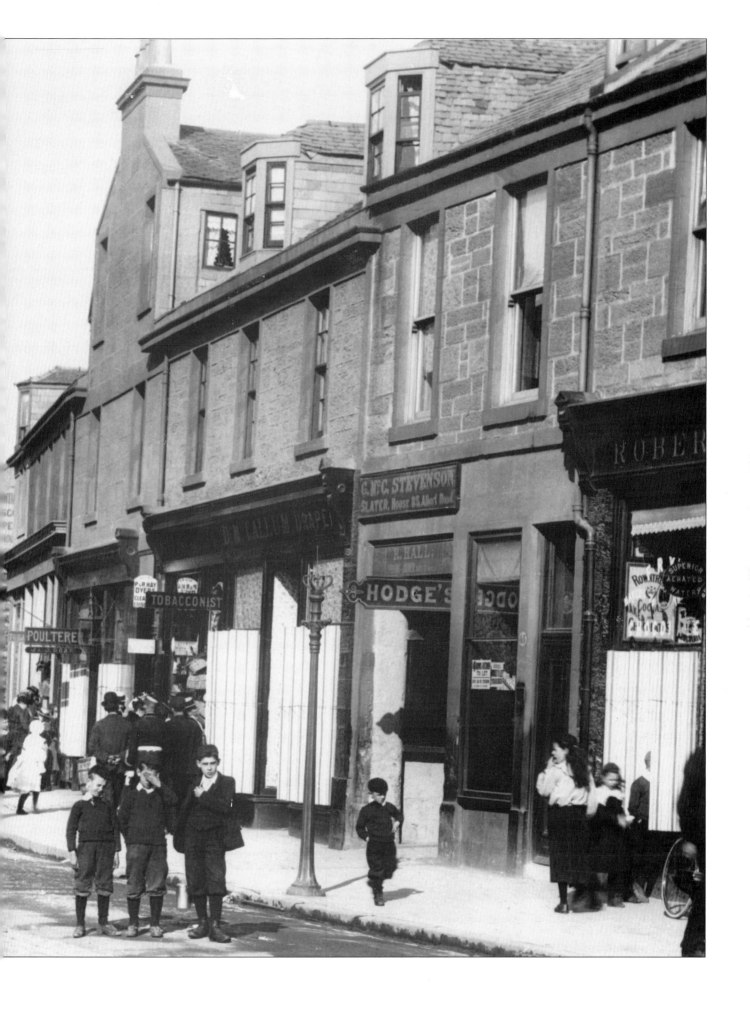

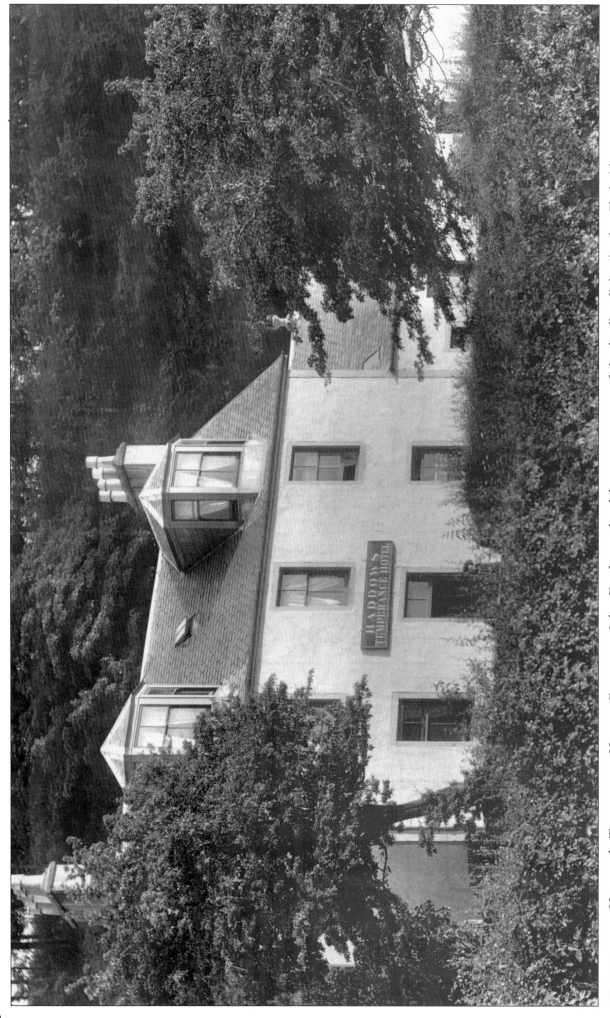

HADDOW'S TEMPERANCE HOTEL, GOUROCK. John Dunlop, a local lawyer was one of the leading lights in the Clydeside temperance movement, founding the first society in the 1820s. By 1876 the Independent Order of Good Templars had 84,000 members in Scotland.

PIC45985

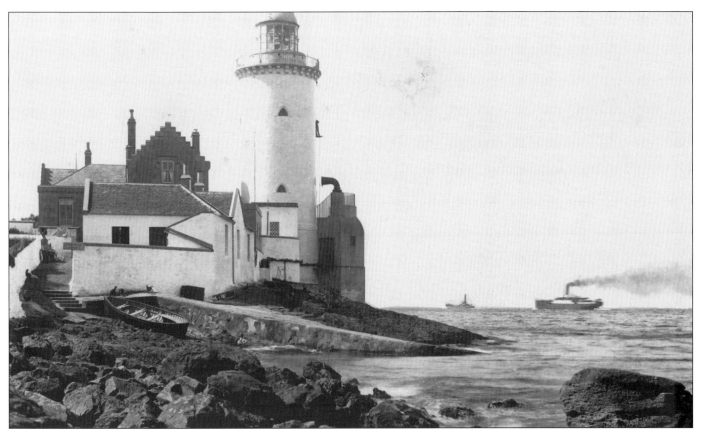

PIC45986 THE LIGHTHOUSE AT CLOCH POINT, BETWEEN GOUROCK AND INVERKIP. Built in 1796, the lighthouse
stands 76 ft high and is a notable Clyde estuary landmark, looking across to the light on the Gantock rocks.

PIC45987 THE PILOT'S COTTAGE AT CLOCH POINT IN 1900. During the Second World War an anti-submarine
boom ran across the river from Cloch Point to the Gantocks. Additional defenses comprised fixed gun positions at
Cloch Point, Toward Point and on Castle Hill, Dunoon.

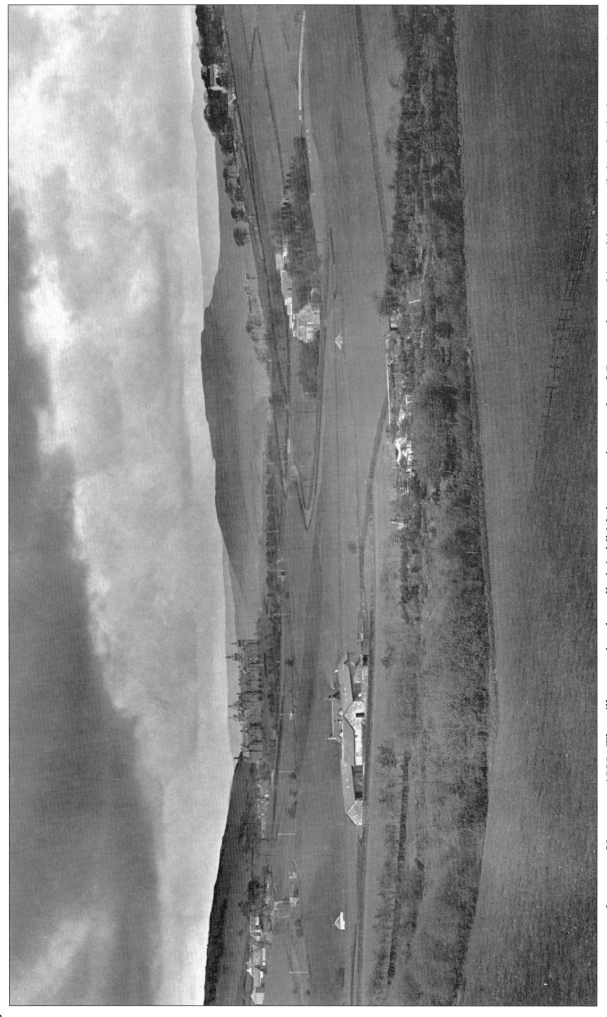

PIC43411 INVERKIP VALLEY IN 1899. The village used to be called Auldkirk because the people of Greenock worshipped here until they built their own church at the end of the sixteenth century. In 1640 witch mania was rife throughout Scotland. The General Assembly instructed ministers to 'take notice of witches, charmers and all such abusers of the people'. Inverkip joined in the burnings, becoming a notorious centre for following the Bible's demand that, 'Thou shalt not suffer a witch to live'.

CLYDEBANK

Situated on the Clyde opposite the mouth of the River Cart, Clydebank was little more than farmland until 1871-72, when J & G Thomson began the construction of a shipyard. At first there were no houses for the yard's workers; they were ferried to and from Glasgow by steamer. Clydebank with its six building berths went into production in 1872 with three steamers for Thomas Skinner of Glasgow. A town eventually grew up on land behind the shipyard, the choice of name for it being a toss-up between Kilbowie and Clydebank. Clydebank was chosen, the town being named after the shipyard. In 1899 the yard was taken over by John Brown & Co. of Sheffield.

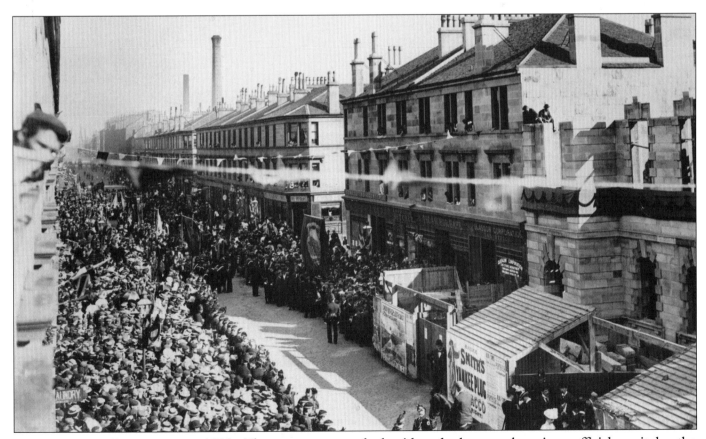

PICC208003 CLYDEBANK IN 1900. The streets are packed with onlookers, and anxious officials wait by the entrance to the site of the new town hall. During the Second World War, Clydebank, given its size suffered the heaviest bombing in Britain. Only seven houses escaped damage, thousands were destroyed or damaged beyond repair and many were hit more than once.

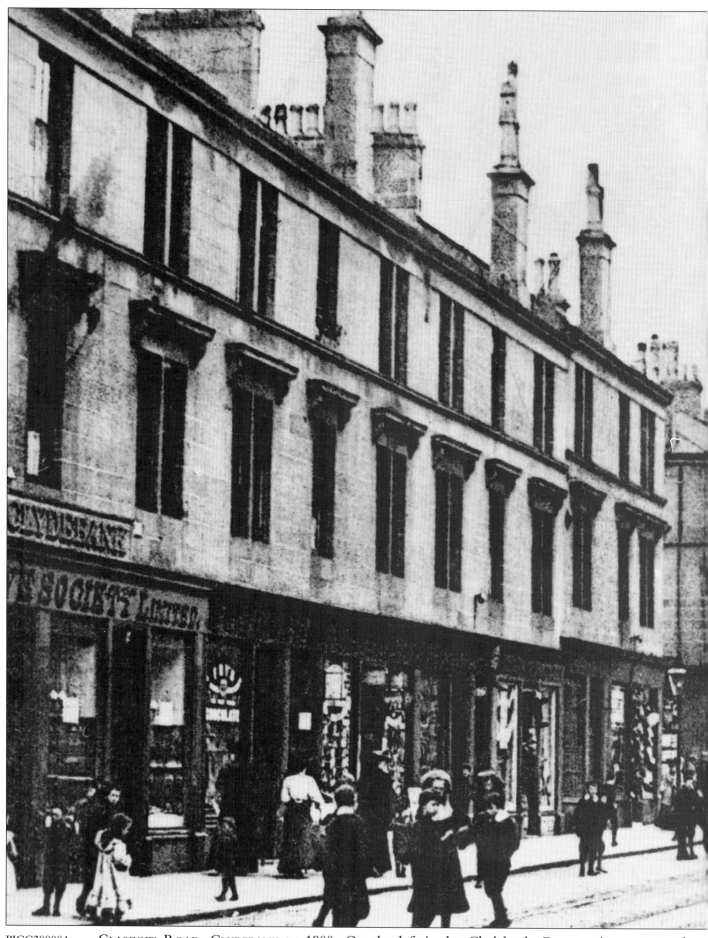

PICC208004 GLASGOW ROAD, CLYDEBANK IN 1900. On the left is the Clydebank Co-operative, a teetotal organisation which banned its members from selling alcohol until 1959.

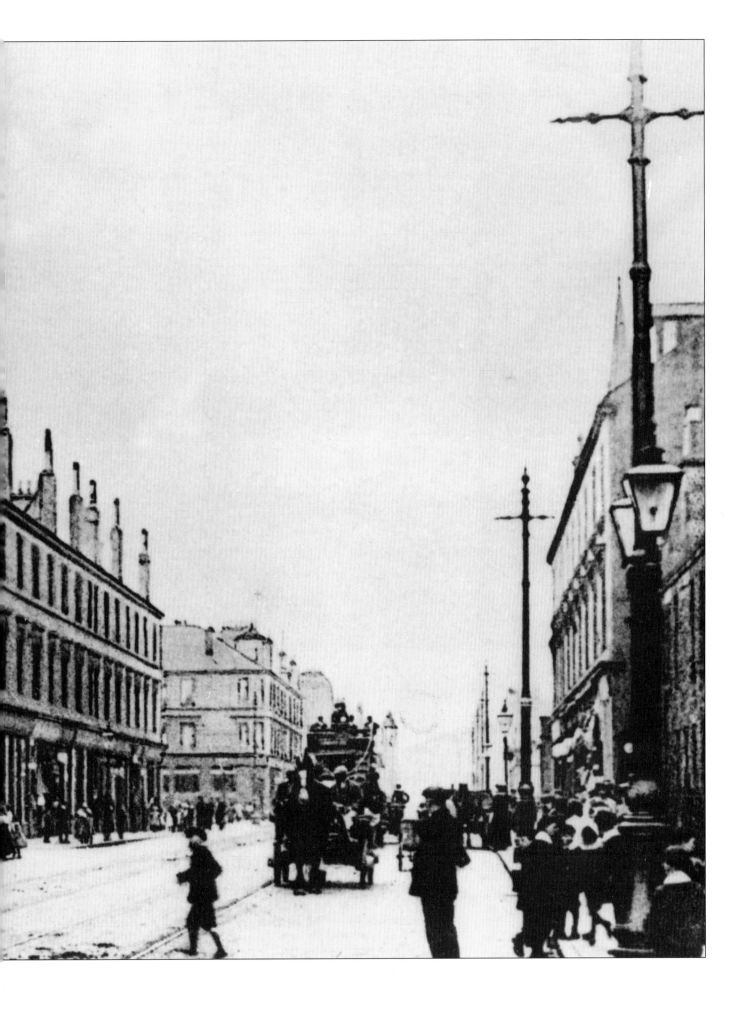

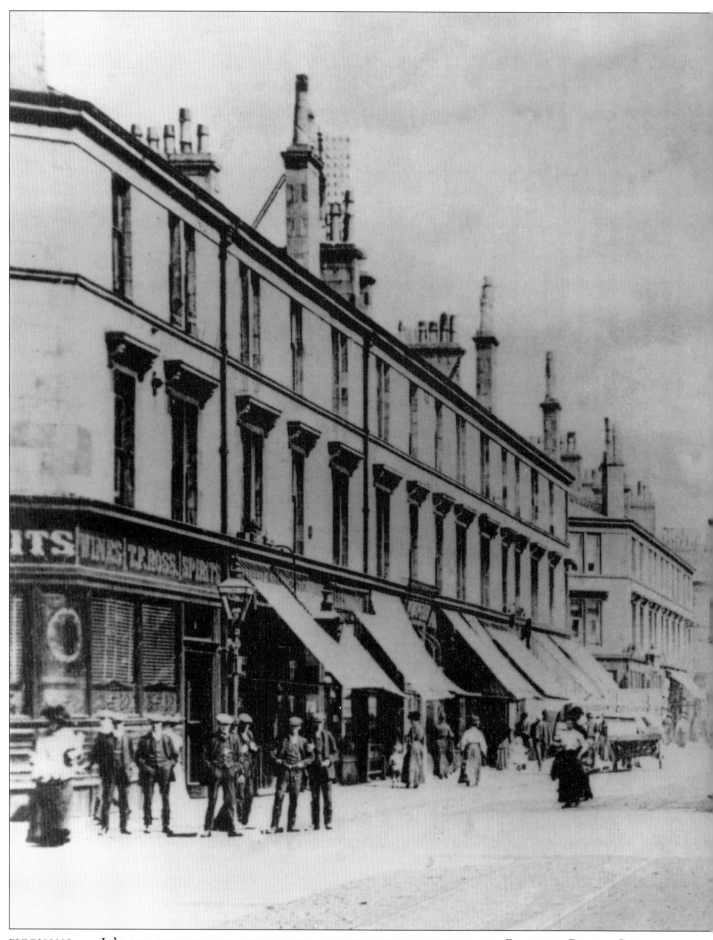

PICC208005 IT'S ALL EYES ON THE CAMERAMAN FOR THIS PICTURE TAKEN ON GLASGOW ROAD, CLYDEBANK.
Electric trams first ran in Glasgow in 1898 on the Mitchell Street to Springburn route. By 1909 there were around
95 miles of double-track tramway, including lines to Govan, Partick, Pollockshaws and Rutherglen. The
Corporation also owned the tramways operating in Milngavie, Clydebank and Renfrew.

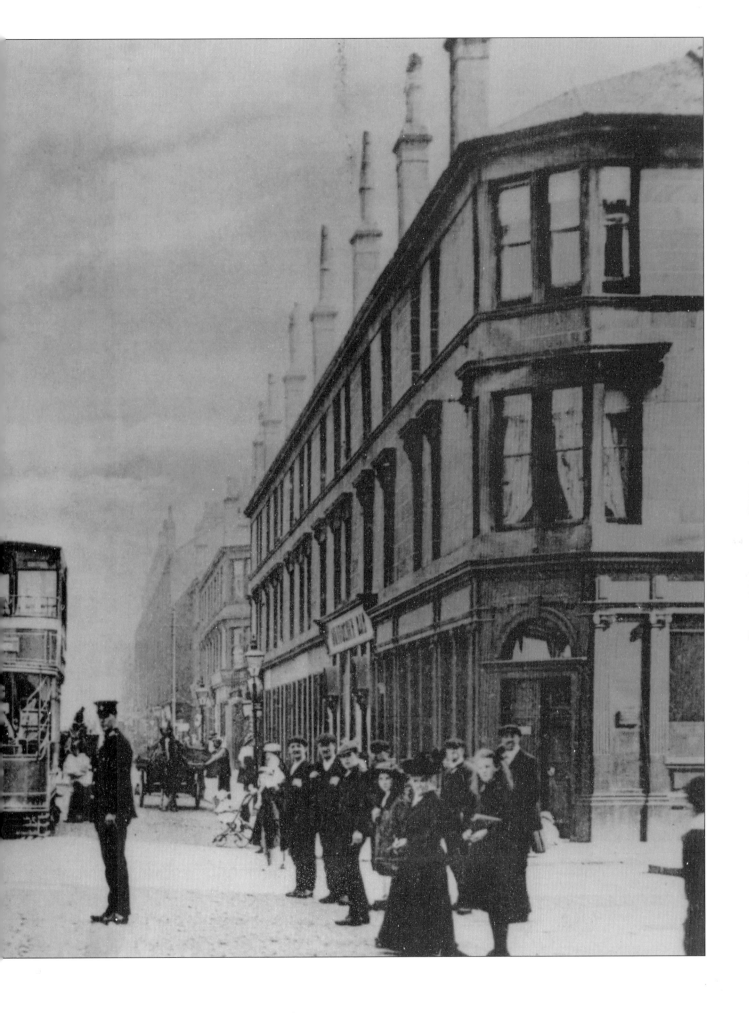

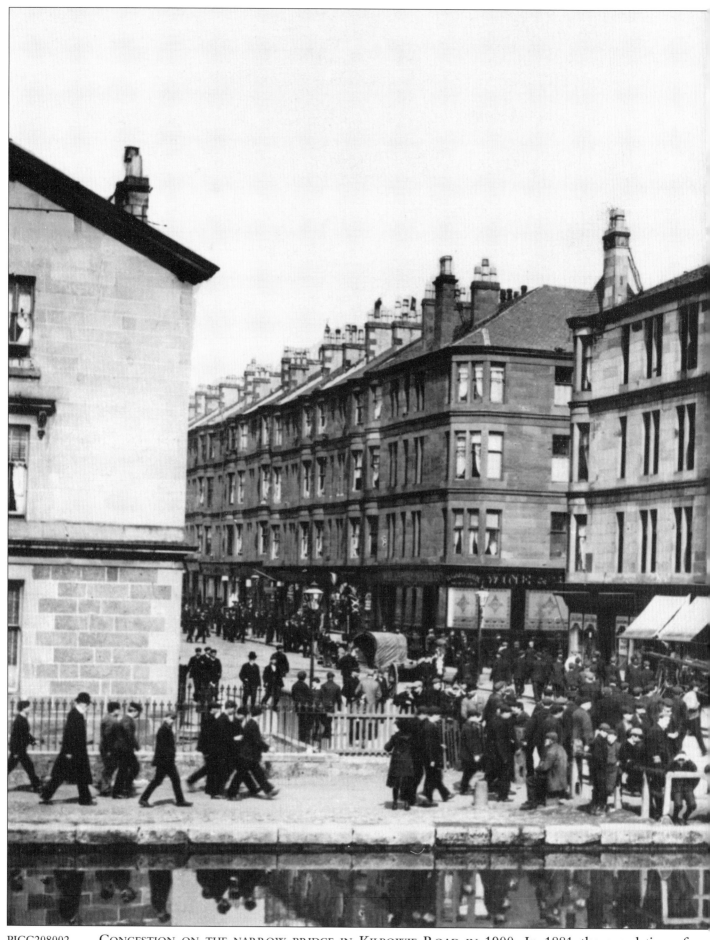

PICC208002 CONGESTION ON THE NARROW BRIDGE IN KILBOWIE ROAD IN 1900. In 1881 the population of Clydebank was 1,600 people, most of whom depended upon the shipyard. In 1882 the American firm of Singers opened a sewing-machine factory, bringing yet more jobs and more people to the area. Clydebank became a burgh in 1886.

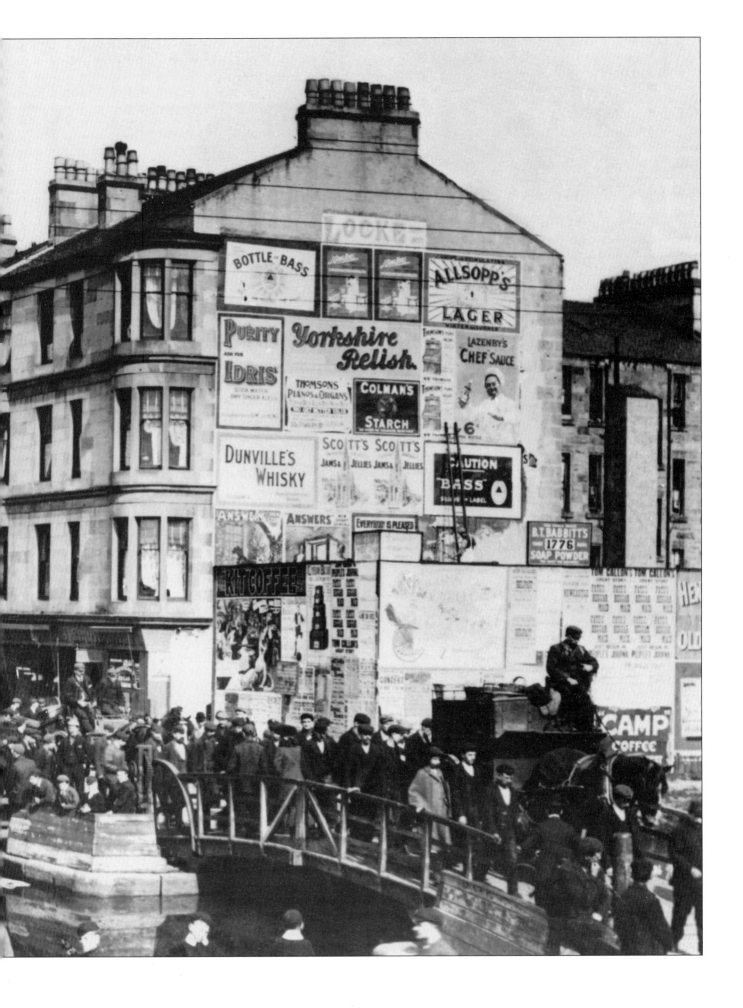

69

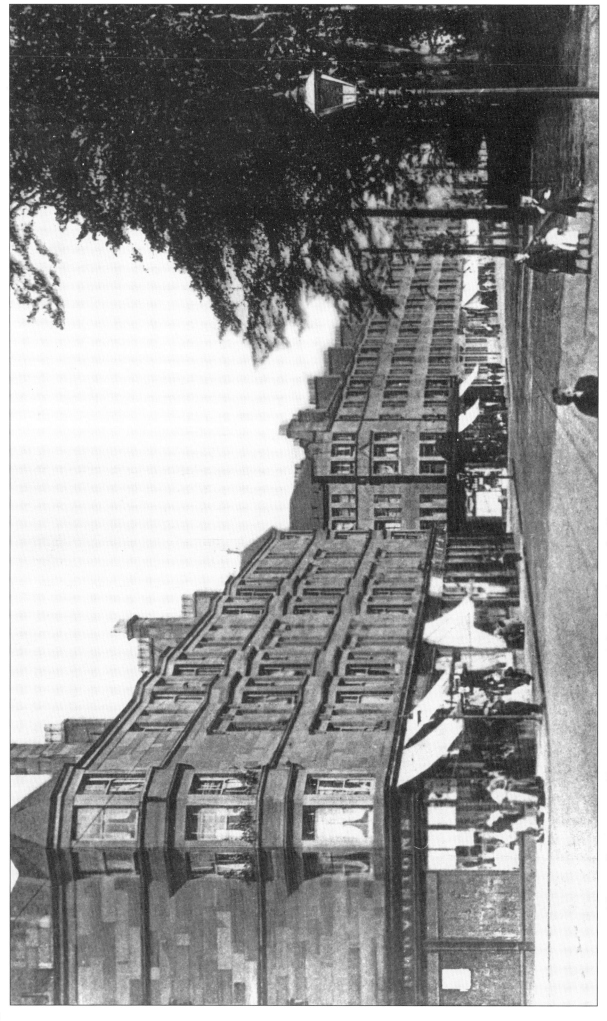

PICC208001 THIS IS BEARDMORE TERRACE, DALMUIR. The Beardmore family were partners in the Parkhead forge and later acquired the Govan East shipyard. The Dalmuir yard was opened in 1905 primarily to build warships, the Govan workforce transferring to the new site. The first ship to be completed was the *Zaza*, a private yacht for William Beardmore.

HELENSBURGH, GARE LOCH & HOLY LOCH

It was Sir James Colquhoun of Luss who first developed Helensburgh in the late eighteenth century as a residential district for those who could afford not to live any nearer to Glasgow than was absolutely necessary. The coming of the railways put Helensburgh into the Glasgow commuter belt, whilst its steamer connections helped it to develop as a holiday centre. On the road to Loch Lomond is the entrance to Glen Fruin, where in 1603 clansmen loyal to Alastair MacGregor of Glenstrae clashed with, or rather massacred 200 members of the Colquhoun clan. The MacGregors had been outlawed for relieving the Colquhouns of a few head of livestock, namely 300 beasts, 100 horses, 400 goats and 400 sheep. The MacGregors were hunted down, the clan proscribed for 173 years.

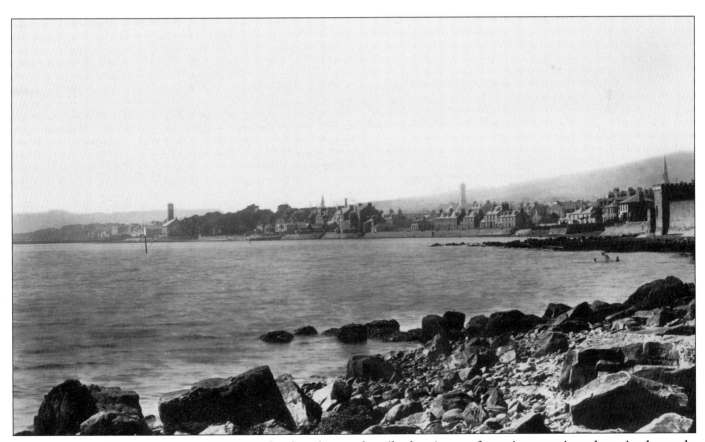

PIC39811 HELENSBURGH IN 1897. Helensburgh was described as '. . . a favourite watering place, is pleasantly situated at the mouth of the Gareloch, and is laid out with the mathematical regularity of an American city.'

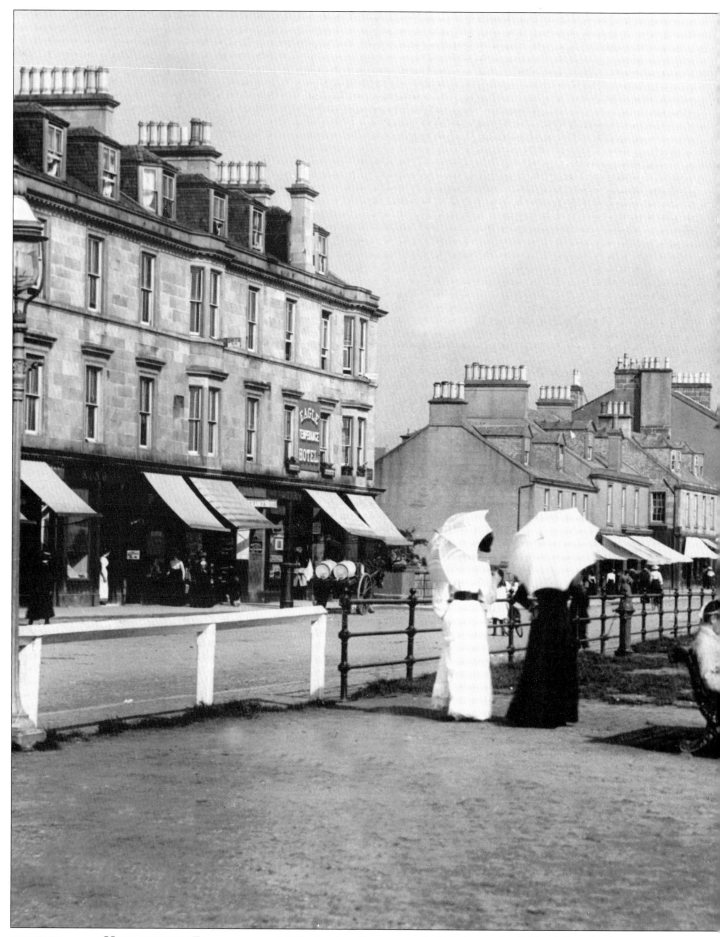

PIC47402 HELENSBURGH ESPLANADE IN 1901. In the distance and slightly to the left of the clock tower is the obelisk erected to the memory of Henry Bell. Another famous son of the town was J Logie Baird, the inventor of television.

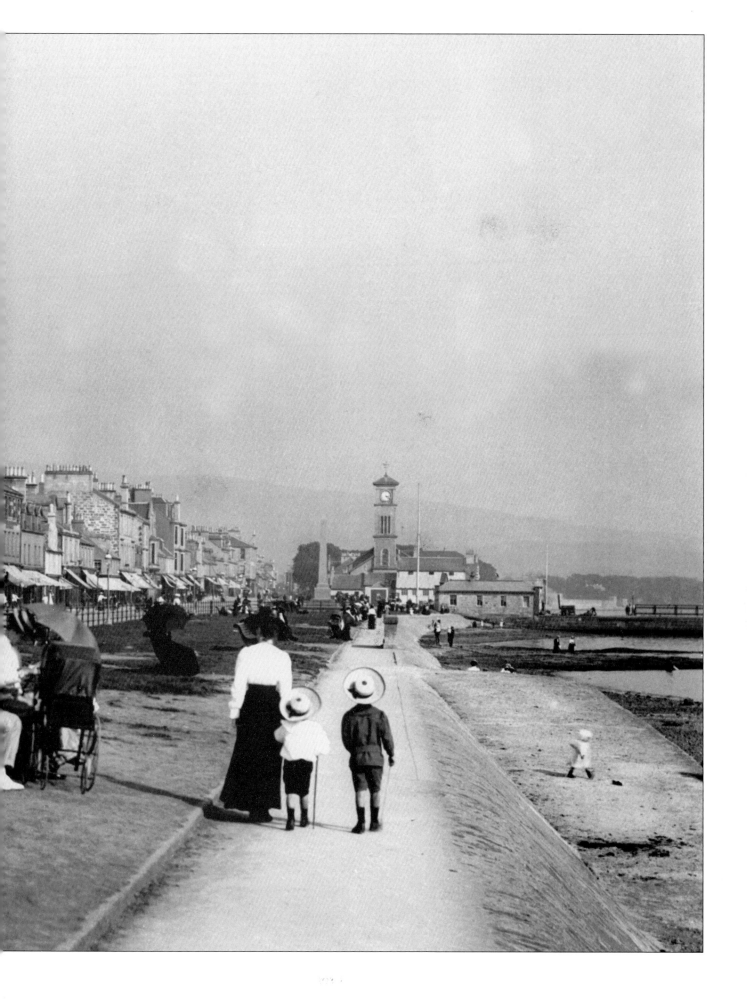

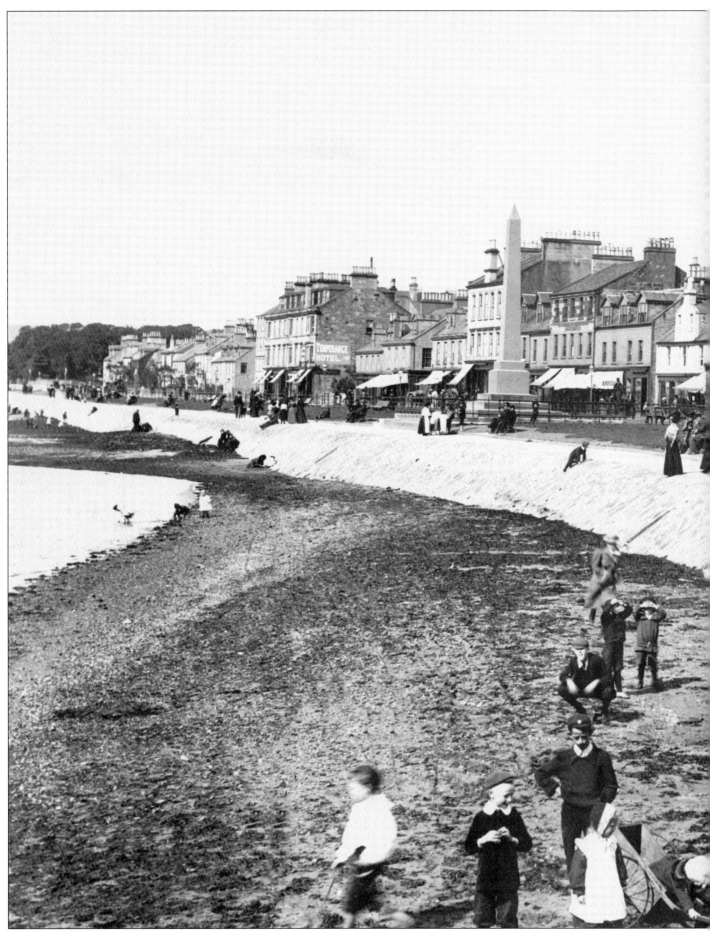

PIC47484 THE ESPLANADE IN 1901. Here we have a good view of the beach, sea wall and the grassed-over area where trippers could sit and relax. Beyond are the Esplanade shops and cafes.

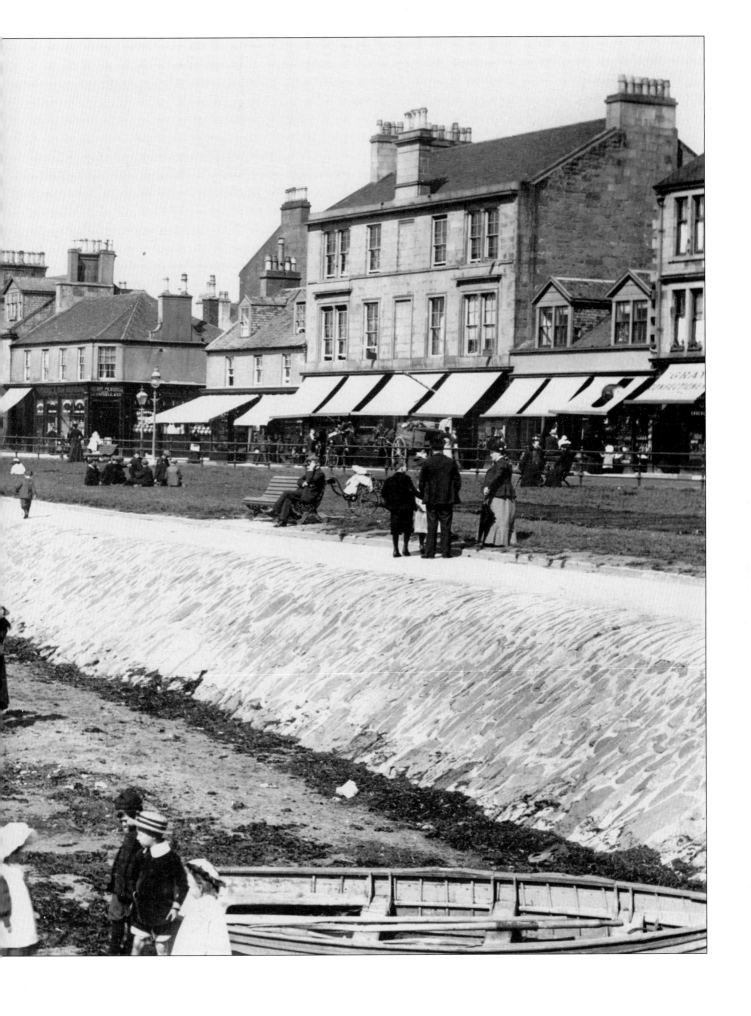

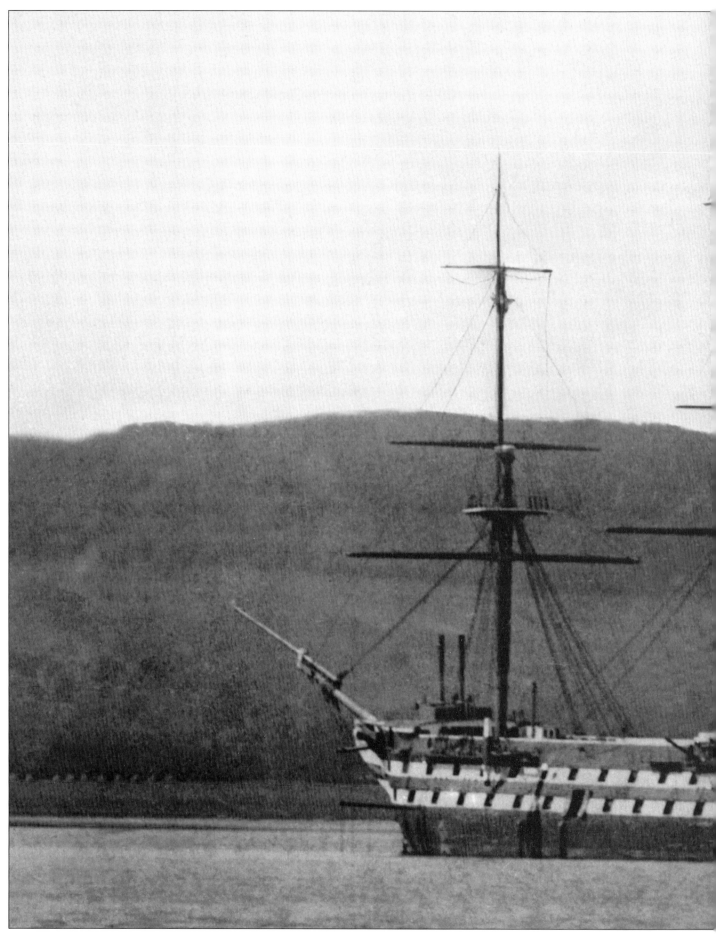

PIC47416 WARSHIP. By 1901 warships from the age of sail had long ceased to have any operational value. However, a surprising number from the 1840s and 50s still survived. Many had been reduced to storage hulks, but others served as accommodation ships, base and headquarters ships and as training vessels.

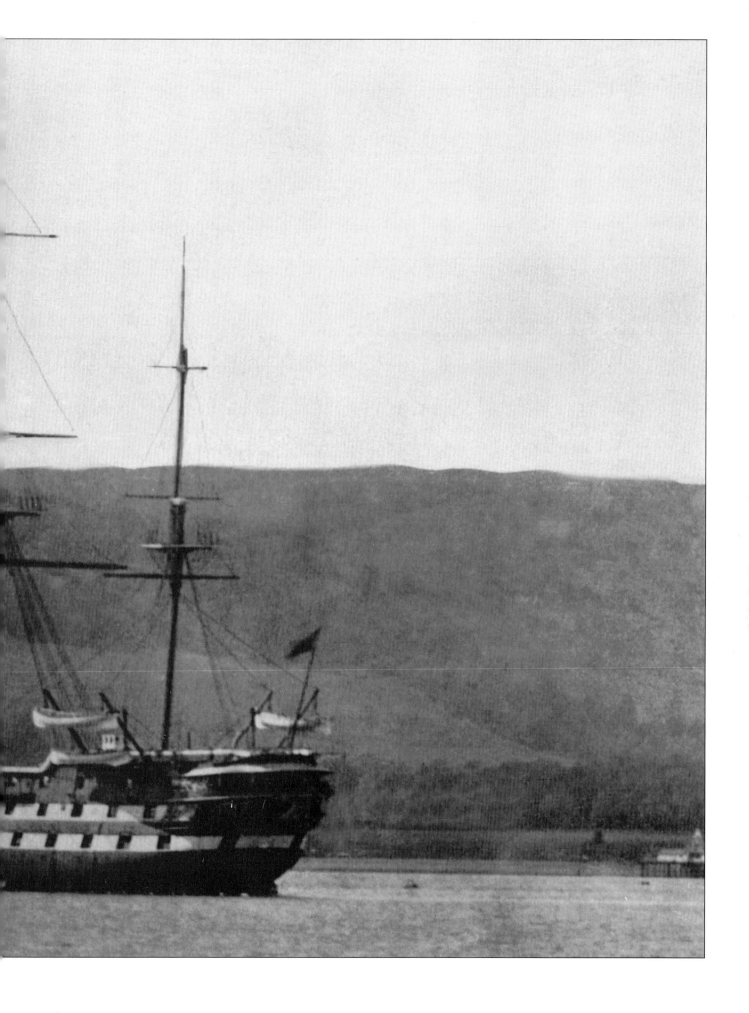

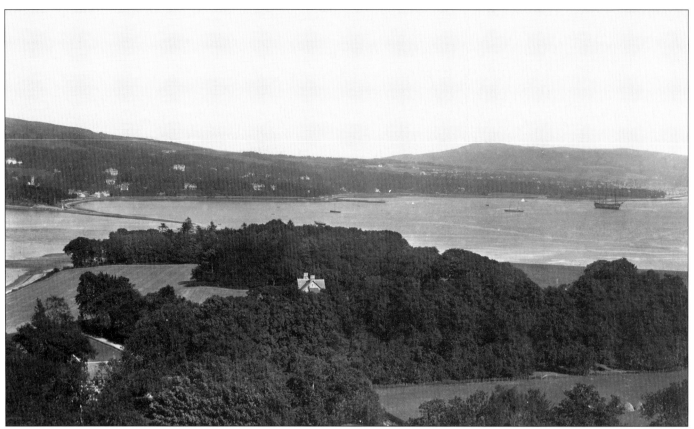

PIC47415 HELENSBURGH, RHU AND THE ENTRANCE TO GARE LOCH PHOTOGRAPHED FROM ROSNEATH IN 1901. Henry Bell, the pioneer of steam navigation in Europe is buried in the churchyard at Rhu. In 1812 Bell launched the steamboat *Comet* on the Clyde, where it operated until 1820.

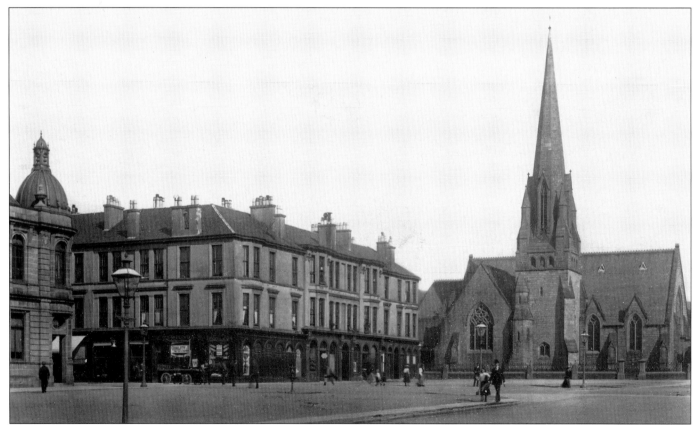

PIC47405 COLQUHOUN SQUARE IN 1901. Helensburgh's leading hotels were the Queen's and the Imperial. During the main season, rooms cost from *3s 6d* a day and dinner was *4s* which is slightly less than what the top Glasgow hotels were charging.

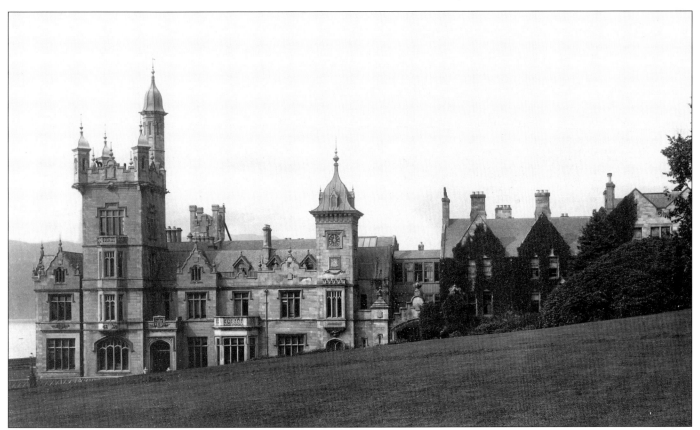

PIC47406 THE SHANDON, A LARGE HYDROPATHIC ESTABLISHMENT STANDING IN ITS OWN GROUNDS. The hydropathic movement started in the 1830s using ordinary water and offering a variety of treatments, including Turkish, Russian, sitz baths, electrical, douche and vapour. Treatment often involved strict dietary regimes and a lot of cold water.

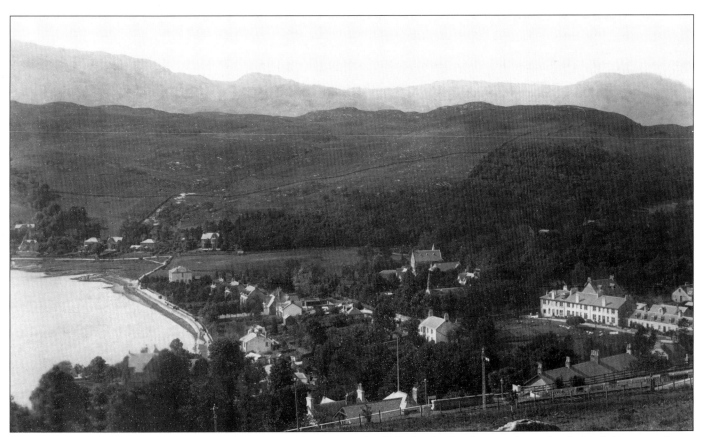

PIC47491 THE VILLAGE OF GARELOCHHEAD IN 1901. The hills in the background overlook Loch Long and are known as Argyll's Bowling Green. In the foreground is the North British Railway Co's line to Fort William and Mallaig.

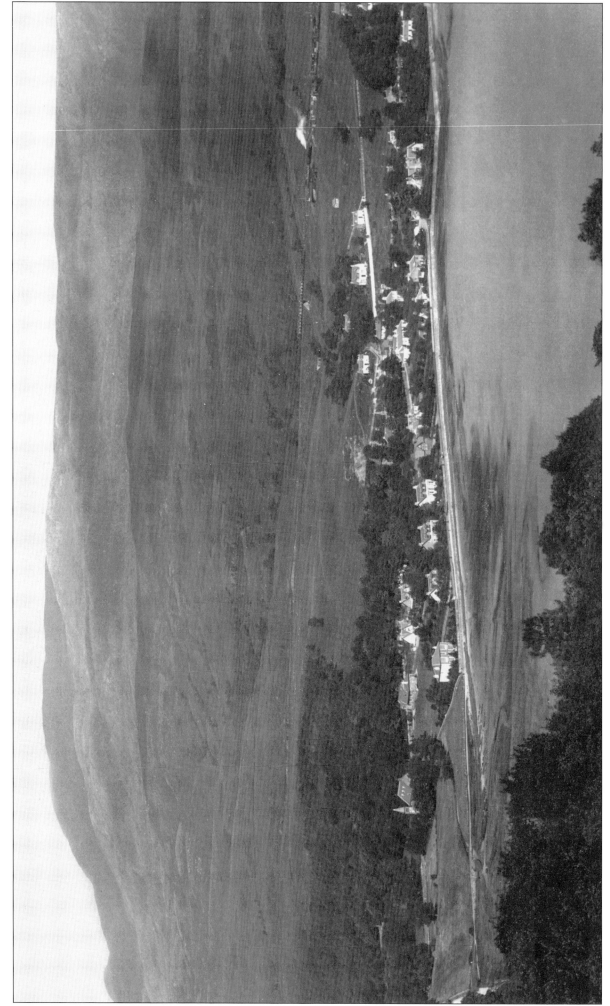

PIC47493 GARELOCHHEAD FROM THE SOUTH-WEST. The Glasgow-bound train standing in the station is almost lost against the high ground overlooking the head of Glen Fruin, where Beinn Chaorach rises to over 2,300 ft. The picture was taken in 1901.

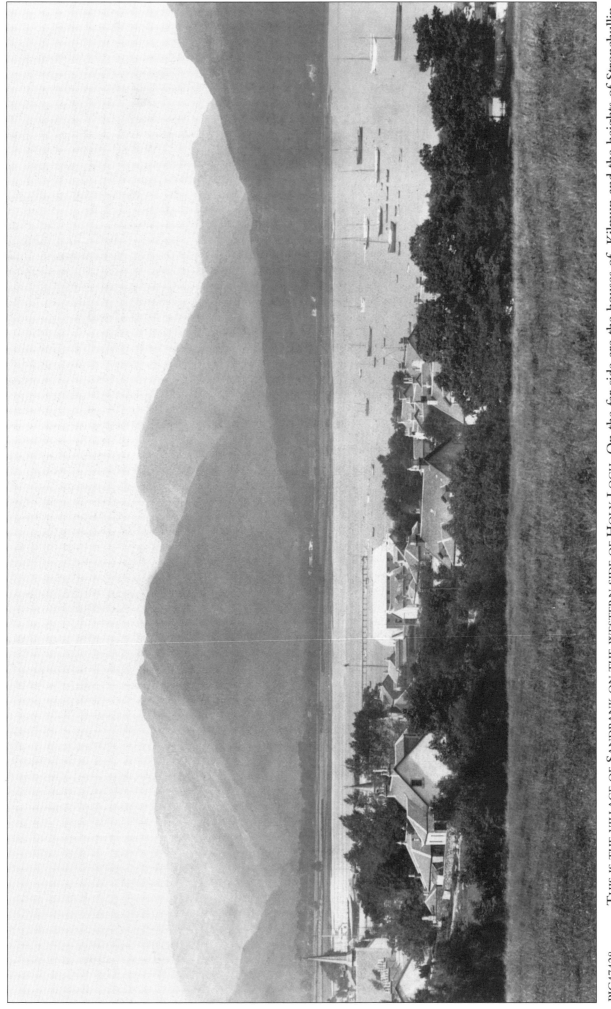

PIC47428 THIS IS THE VILLAGE OF SANDBANK ON THE WESTERN SIDE OF HOLY LOCH. On the far side are the houses of Kilmun and the heights of Stronchullin Hill, Beinn Ruadh and Creachan Mor.

PIC39849 HOLY LOCH IS LITTLE MORE THAN A SMALL INLET THE CLYDE ESTUARY. In the 1960s however, this quiet backwater became internationally famous when it was chosen as a base for the United States Navy nuclear submarine force. The picture dates from 1897, when submarines were still very much in the experimental stage.

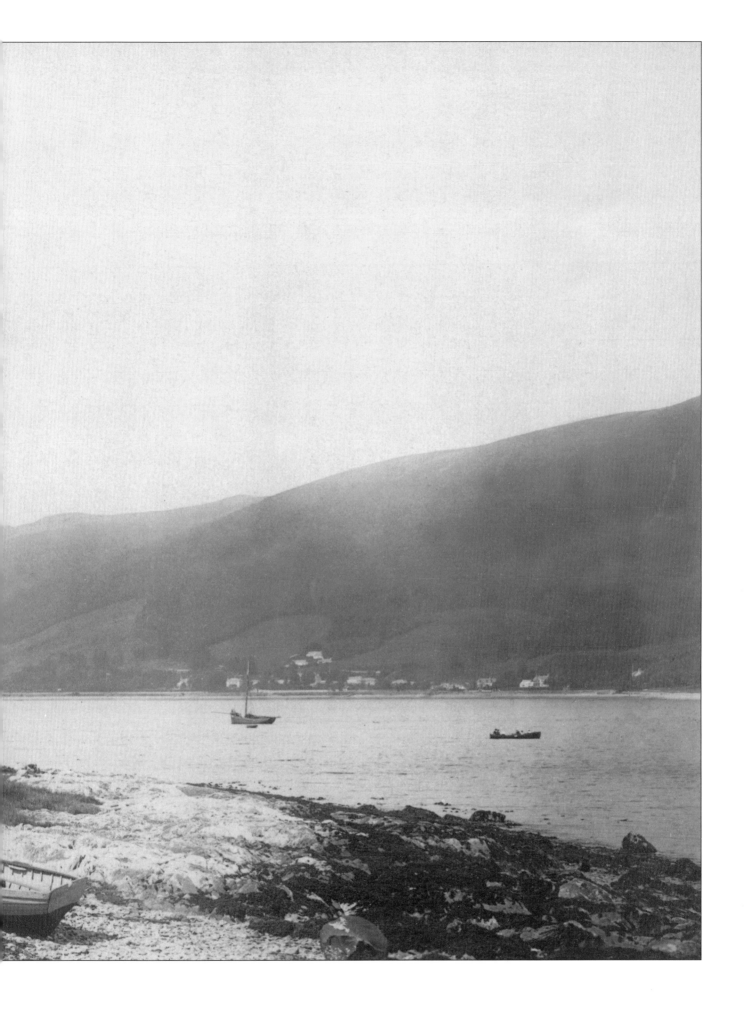

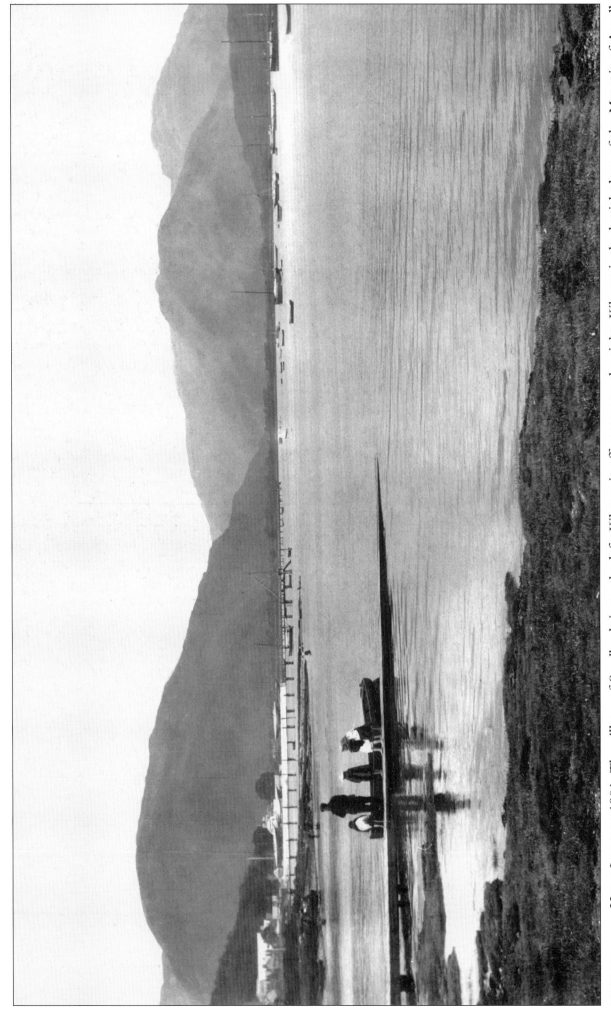

PIC47427 HOLY LOCH IN 1901. The village of Sandbank is on the left, Kilmun is off camera to the right. Kilmun is the burial place of the Marquis of Argyll who was executed in 1661, whilst in the churchyard there is the tombstone of Archibald Clark, a young shepherd, who was found frozen to death at Ardtaric in September 1854.

DUNOON

Until the early nineteenth century Dunoon was nothing more than a small village clustered round a castle. The popularity of the Clyde excursion steamers changed all that, and within a short space of time Dunoon developed into a holiday resort, the largest and best known on the Cowal.

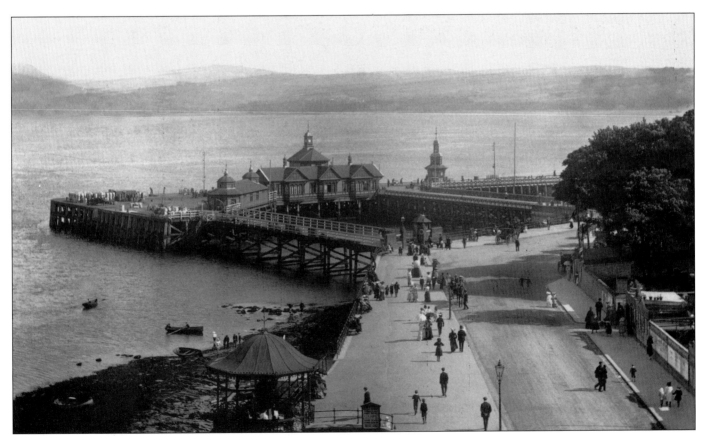

PIC52618 DUNOON PIER DEVOID OF SHIPPING. During the early 1880s problems with drunken Glaswegians running amok in the coastal towns, had led to the withdrawal of Sunday excursion sailings. With pubs in Glasgow being shut on the Sabbath, the only place to get a drink had been onboard an excursion steamer.

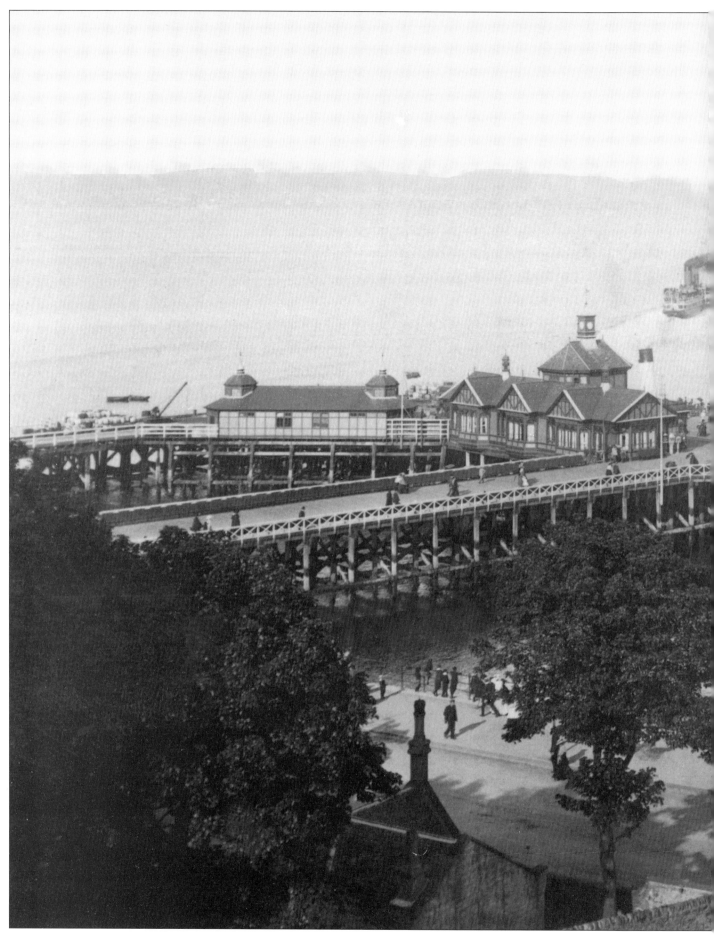

PIC52620 A BUSY DUNOON PIER IN 1904. One steamer has just departed and there are two others berthed alongside. The one on the right appears to belong to the North British Railway, whilst the one on the left has funnel colours associated with Capt John Williams and could be the Strathmore. In any one year Dunoon could expect to handle around 10,000 calls by steamers.

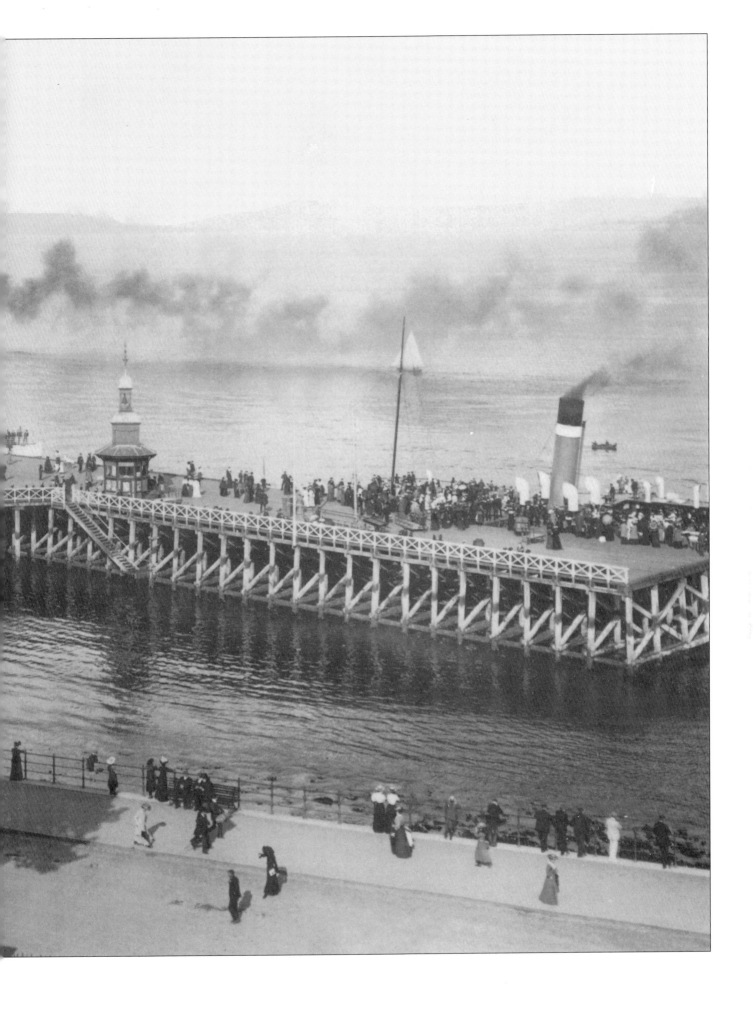

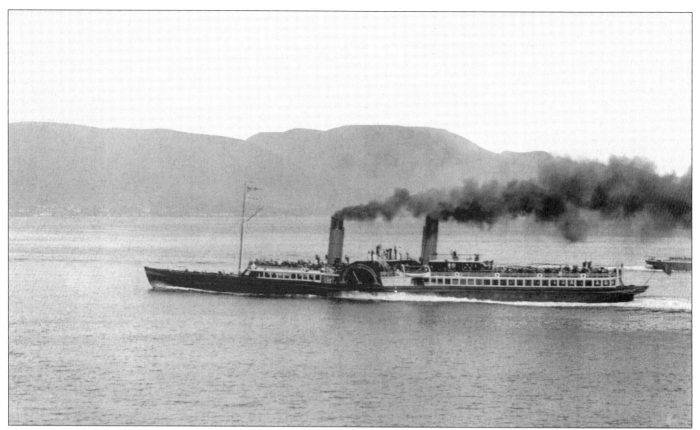

PIC 52621 THE MACBRAYNE STEAMER *Columba* PICKS UP SPEED AS SHE PULLS AWAY FROM DUNOON. Built in 1878 and flagship of the MacBrayne fleet, *Columba* was renowned for the quality of her passenger comfort, with saloons the full width of her hull, a barber's shop and a post office. When first commissioned, she was placed on the up-market daily run from Glasgow to Tarbert and Ardrishaig, by way of Greenock, Dunoon, Rothesay and the Kyles of Bute. The picture was taken in 1904.

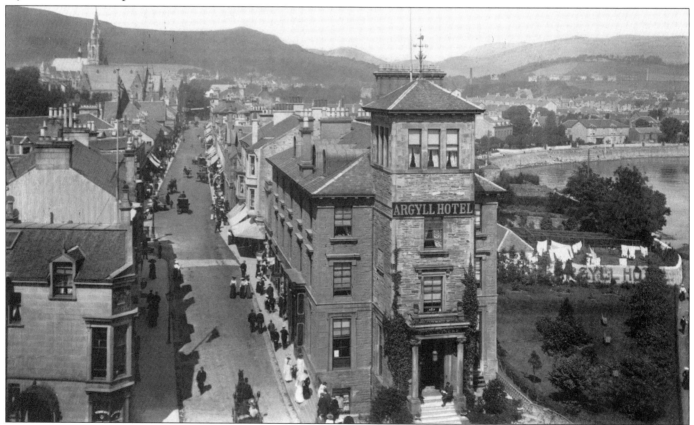

PIC52614 THE ARGYLL HOTEL was one of three recommended to overseas visitors; the others were the Queen's and McColl's. It was also possible to hire apartments at around 15*s* a week during the main season.

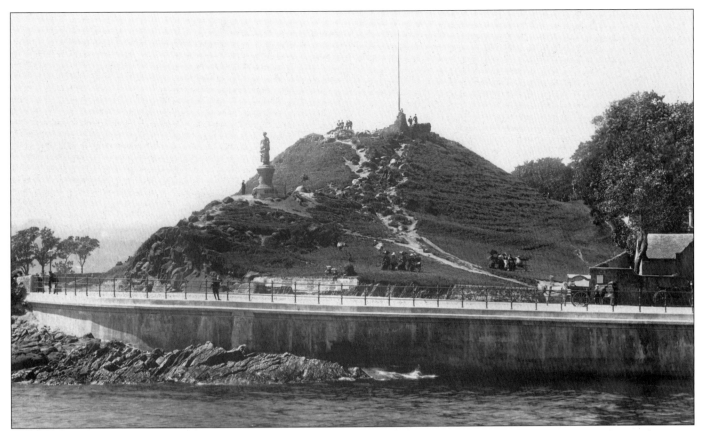

PIC39831 VISITORS CLAMBER OVER THE SITE OF THE OLD CASTLE. The modern castle is comparatively new, being completed in 1822. The statue is of Burns's Highland Mary, who was born at Auchnamore Farm nearby. The statue was erected in 1896.

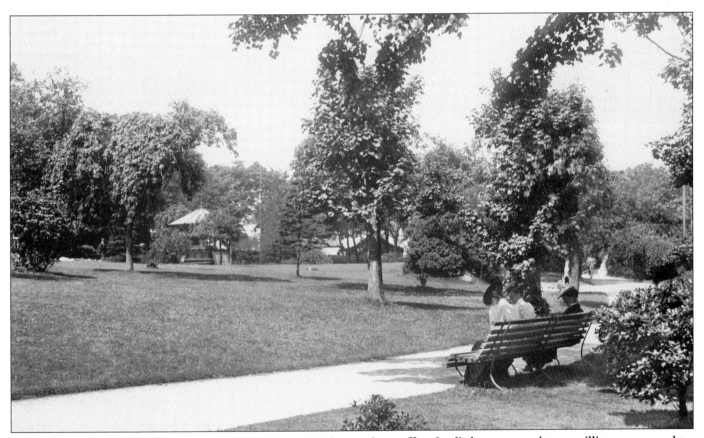

PIC39832 THE CASTLE GARDENS AT DUNOON. The gardens offered a little peace and tranquillity, compared to the hustle and bustle of the town. The picture might have been taken on a Sunday; it was at the time when the Clyde excursion steamers did not sail on the Sabbath.

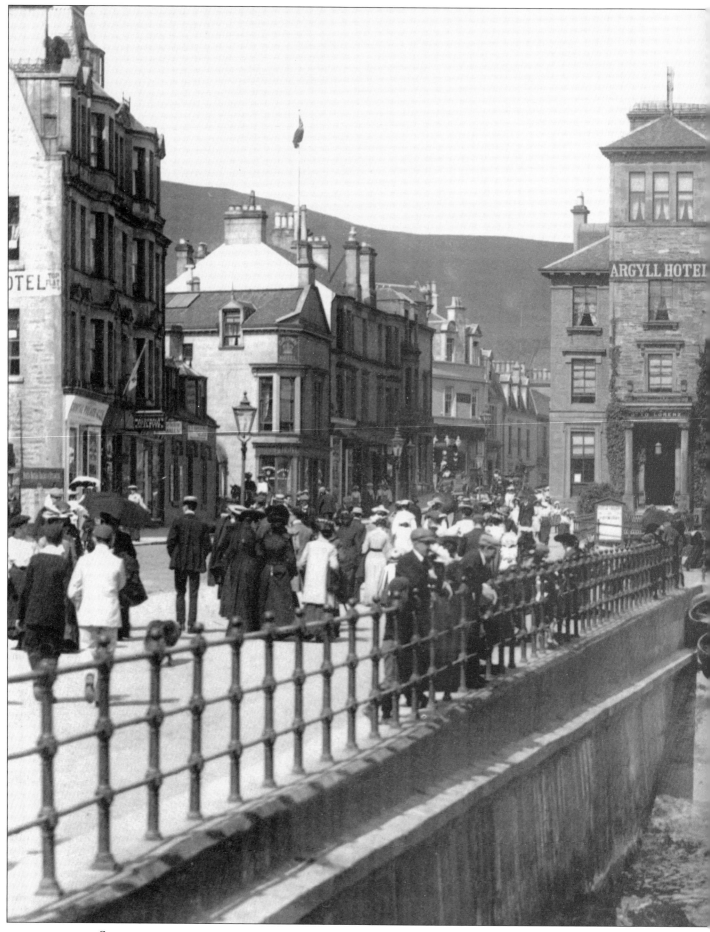

PIC52613 SUNDAY TRIPPERS MAKE THEIR WAY FROM THE PIER TO ARGYLL STREET. Dunoon being the largest and best known of the Cowal resorts, its main steamer links were with Gourock, Rothesay and with the North British Railway at Raigendoran. It was also an interchange for those passengers wishing to take the Oban steamer.

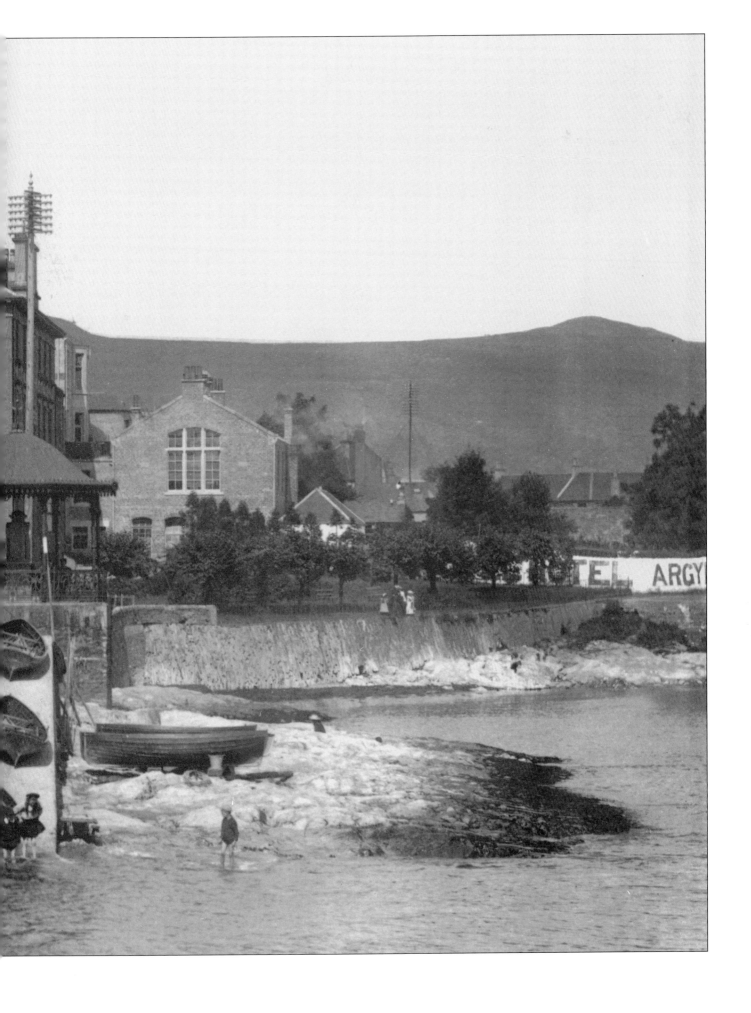

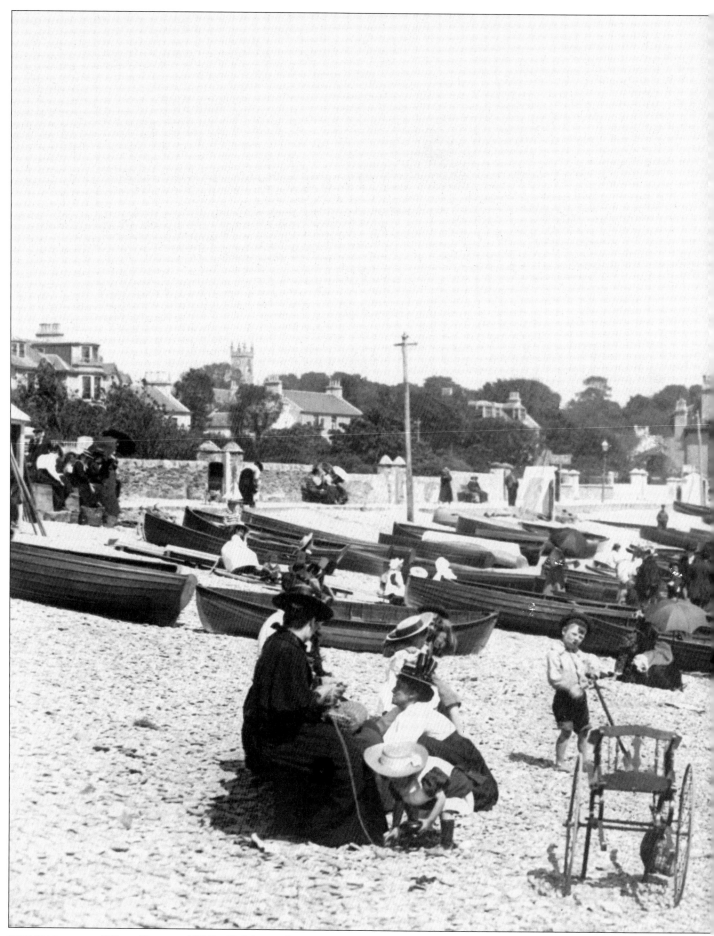

PIC39829 WEST BAY IN 1897. Children play on the beach and paddle in the sea, whilst their mums have the chance to knit while they natter. In the days before deckchairs, was it possible to hire benches to sit on?

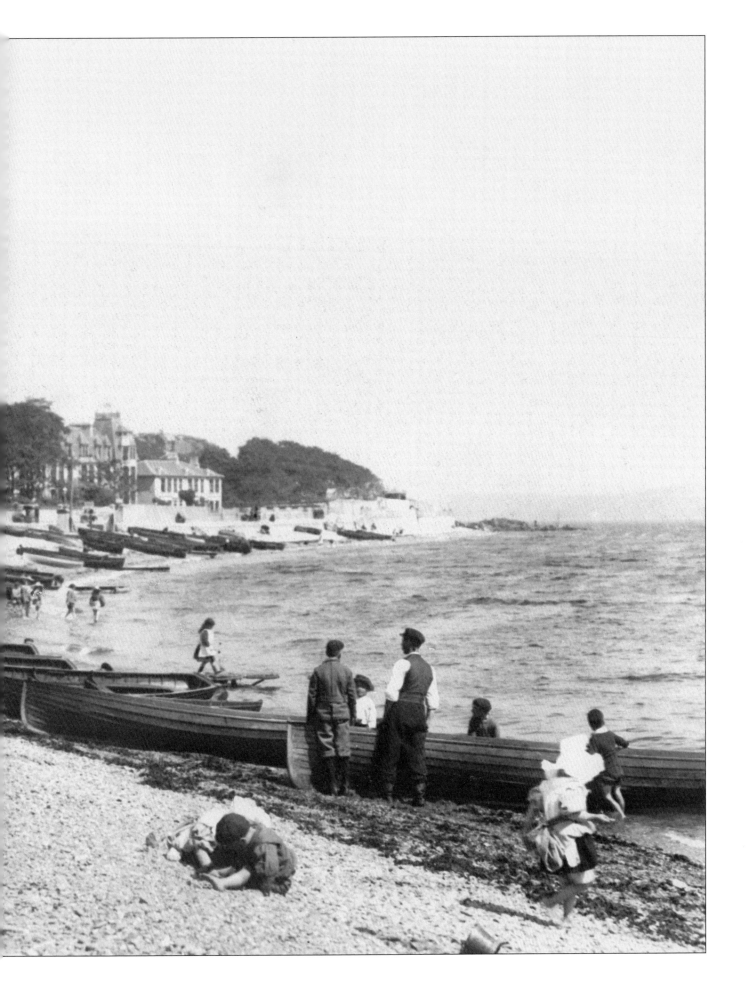

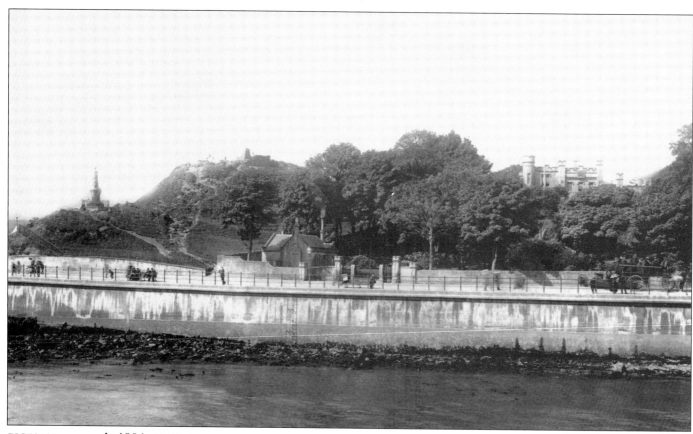

PIC52616 A 1904 VIEW OF THE PIER ESPLANADE, CASTLE ROCK AND THE NEW CASTLE. There were no trams serving Dunoon, but there were a number of horse-drawn omnibuses working between the West and East Bays. One of them is just in this picture on the extreme right.

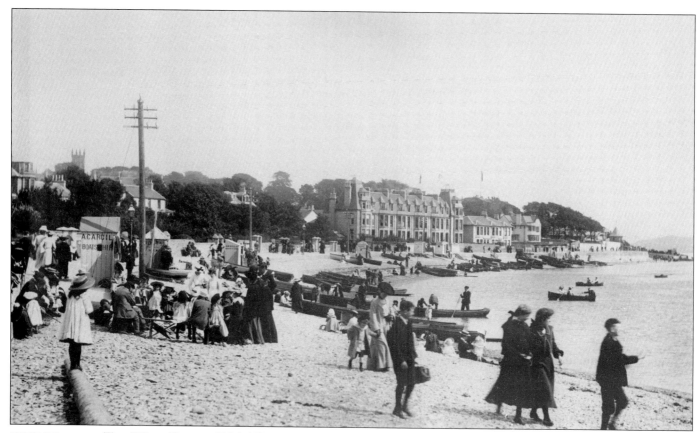

PIC52615 THE WEST BAY IN 1904. The group of people on the left appear to be on a well prepared outing and are having a picnic. The small huts are where you hired your boat from, for a by-the-hour row round the bay.

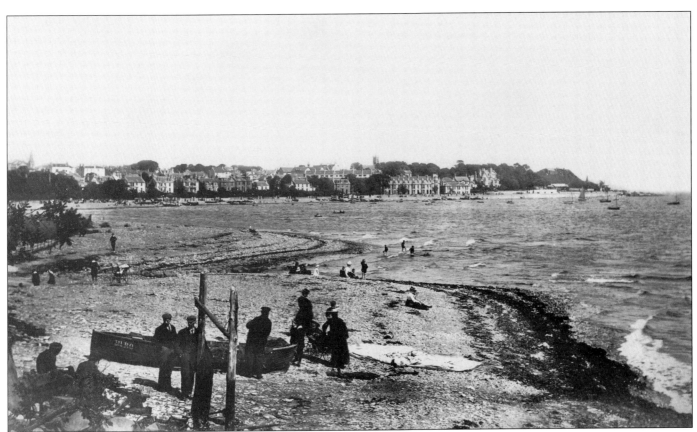

PIC47421 THE WEST BAY IN 1901. Local fisherman work on their boat; the large piece of material on the beach is probably the sail. A popular place for a paddle, though none of the Frith Collection pictures show any bathing machines, which were such a feature of the English resorts.

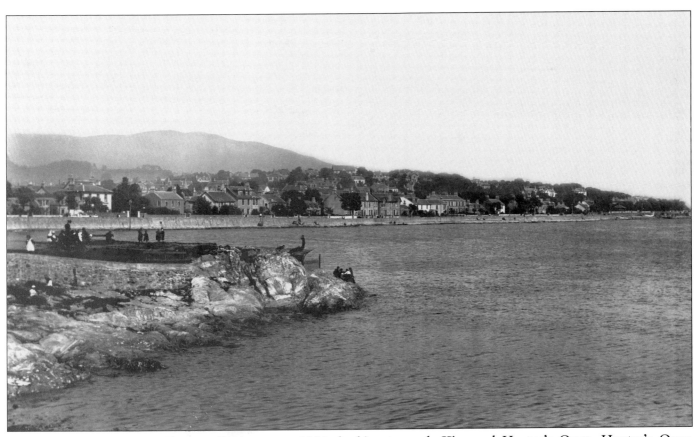

PIC47418 THE EAST BAY AT DUNOON IN 1901, looking towards Kirn and Hunter's Quay. Hunter's Quay became the headquarters for the Clyde Yachting Club, and the annual Clyde Yachting Fortnight. It gets its name from the Hunter family of Hafton House.

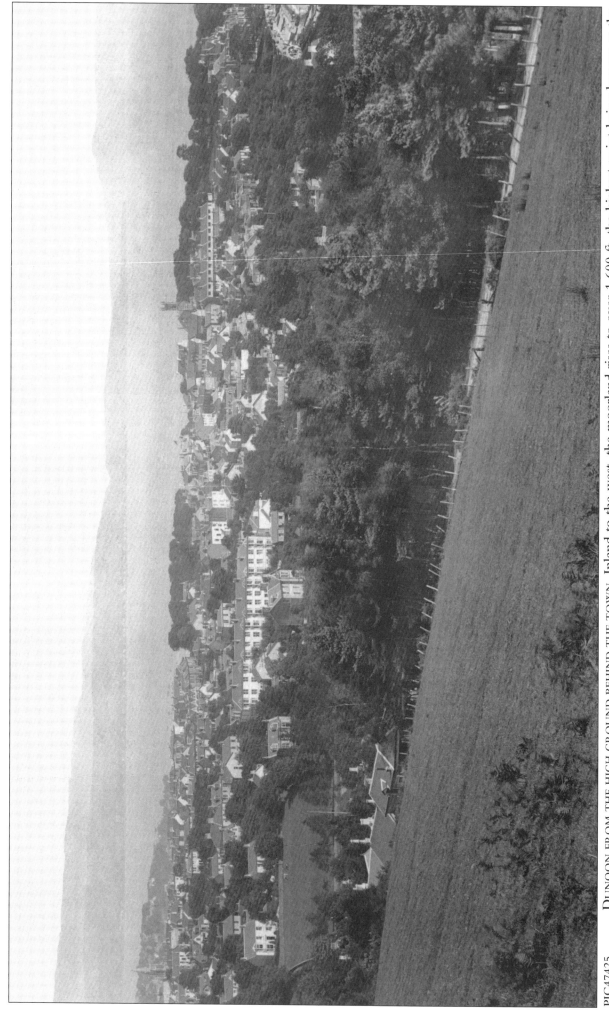

PIC47425 DUNOON FROM THE HIGH GROUND BEHIND THE TOWN. Inland to the west, the moorland rises to over 1,600 ft, the highest point being known as the Bishop's Seat.

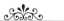

THE KYLES OF BUTE
ROTHESAY

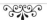

The first effective spinning mill in the West of Scotland was built at Rothesay. Between 1787 and 1834, the number of cotton mills opened in Scotland rocketed from just 19 to 134. During the American Civil War imports of cotton fell from 8,600 tons in 1861, to 500 tons in 1862 and 350 tons in 1864. The effects of the naval blockade by the North on Confederate ports caused severe distress and hardship amongst British mill workers.

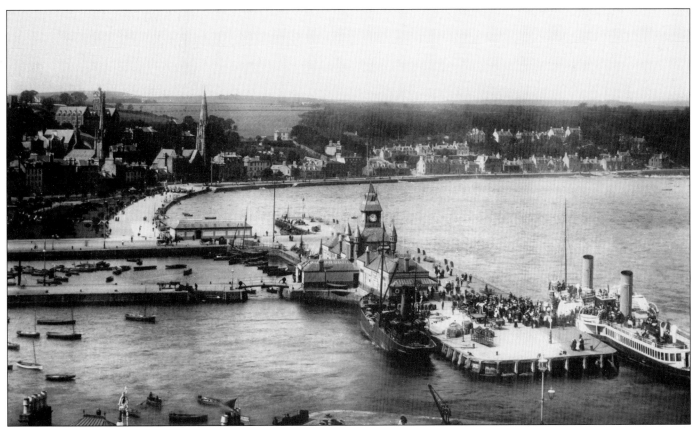

PIC45990 A VIEW OF ROTHESAY PIER IN 1900.

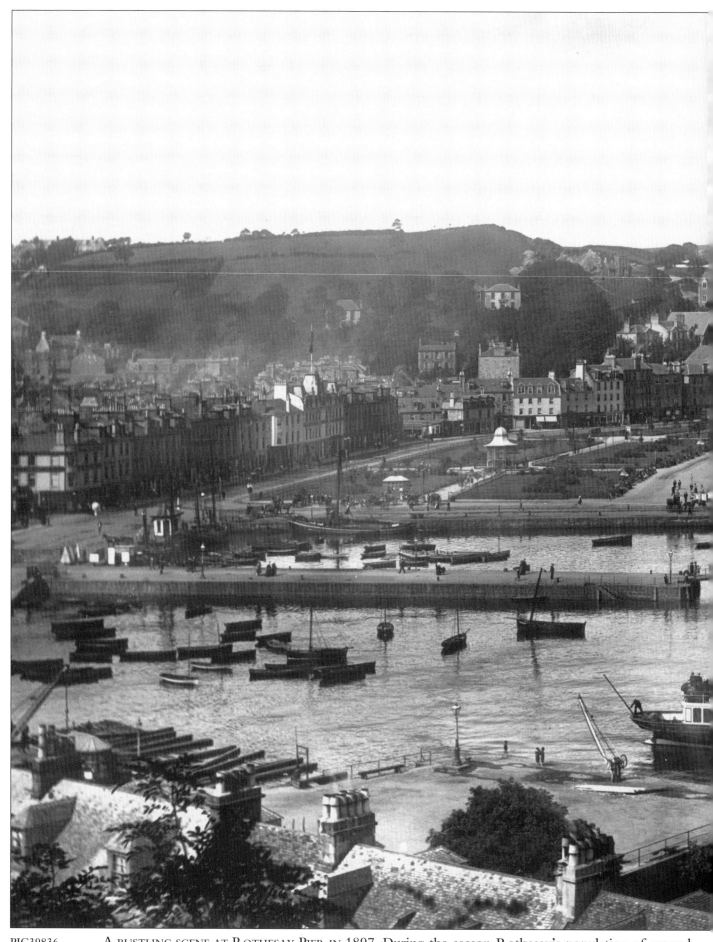

PIC39836 A BUSTLING SCENE AT ROTHESAY PIER IN 1897. During the season Rothesay's population of around 9,000 would increase dramatically.

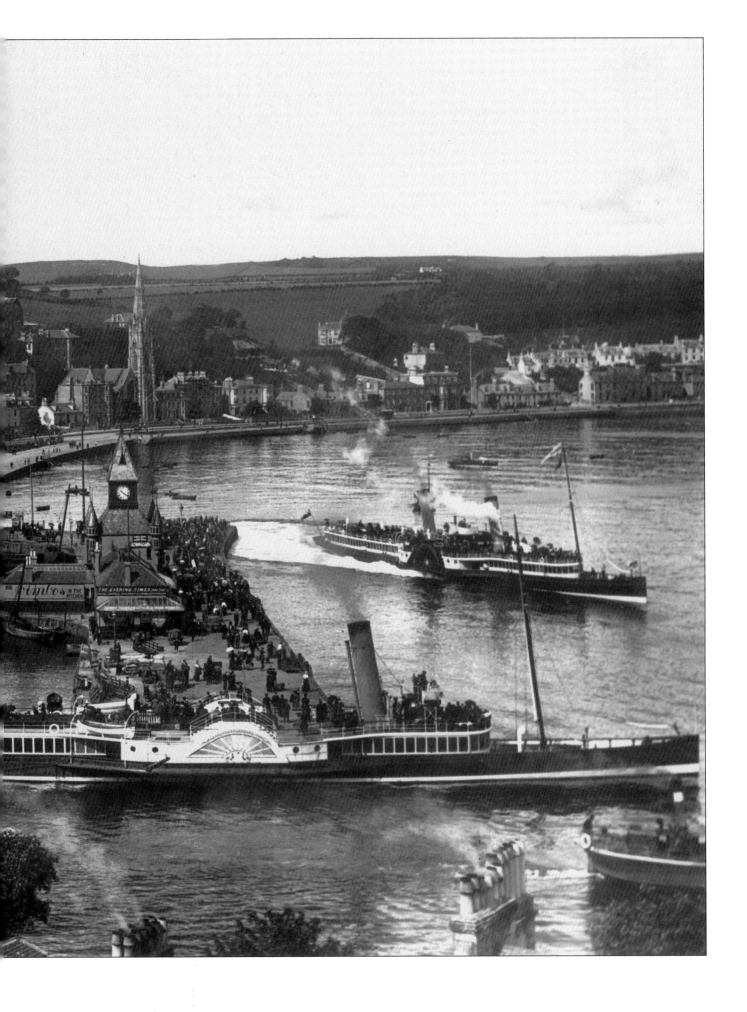

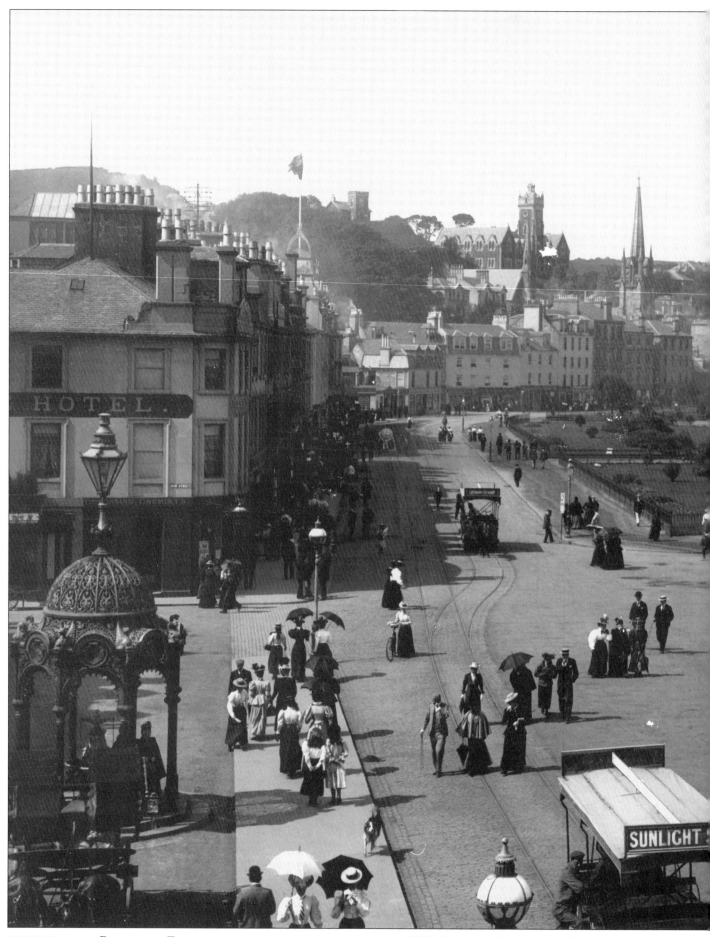

PIC39837 ROTHESAY ESPLANADE ON A SUNNY AFTERNOON IN 1897. Rothesay's main hotels at this time were the Royal, the Queen's, the Bute Arms and the Glenburn Hydropathic. The Esplanade Hotel offered tea, bed and breakfast for 8*s* 6*d* per night.

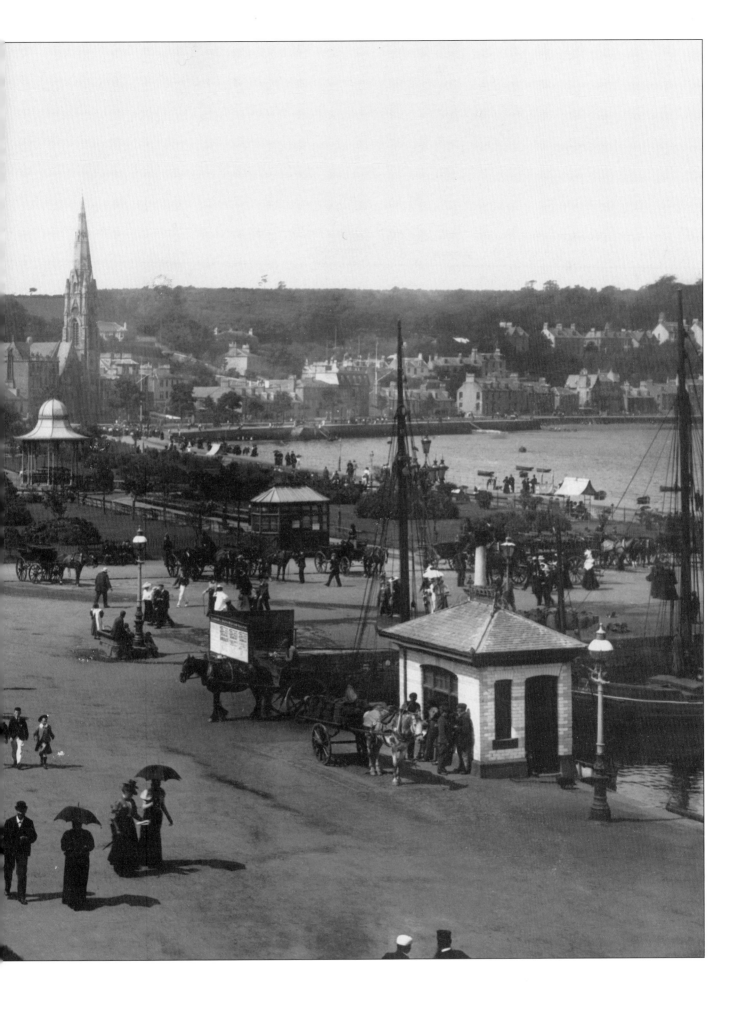

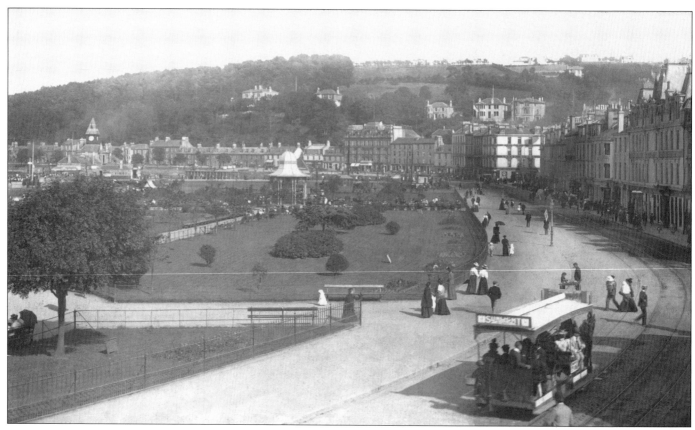

PIC39838 A HORSE-TRAM FROM PORT BANNATYNE MAKES ITS WAY ALONG ROTHESAY ESPLANADE. The tramway extended to Ettrick Bay on the west coast and was electrified in 1902.

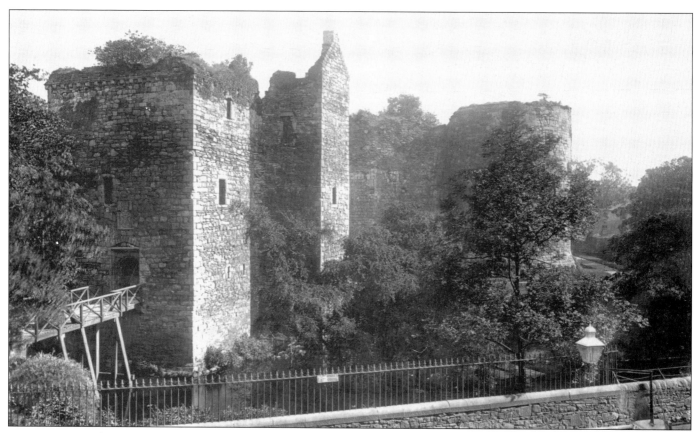

PIC39845 THE MOATED RUINS OF ROTHESAY CASTLE AS THEY LOOKED IN 1897. An earlier castle on the site was captured in 1263 by King Haco of Norway and subsequently demolished, allegedly on the orders of Robert The Bruce. A new stronger fortress was then built in its place.

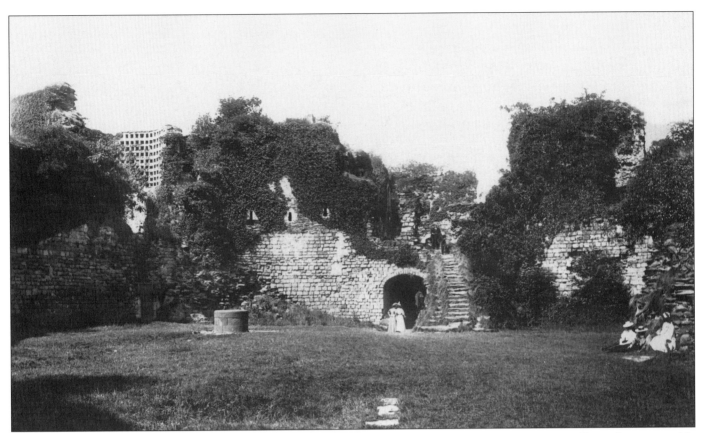

PIC39844 PART OF THE CIRCULAR COURTYARD OF THE THIRTEENTH CENTURY CASTLE. A favourite spot with Victorian visitors for a picnic. On the left can be seen the honeycomb internal stonework of one of the turrets. This picture dates from 1897.

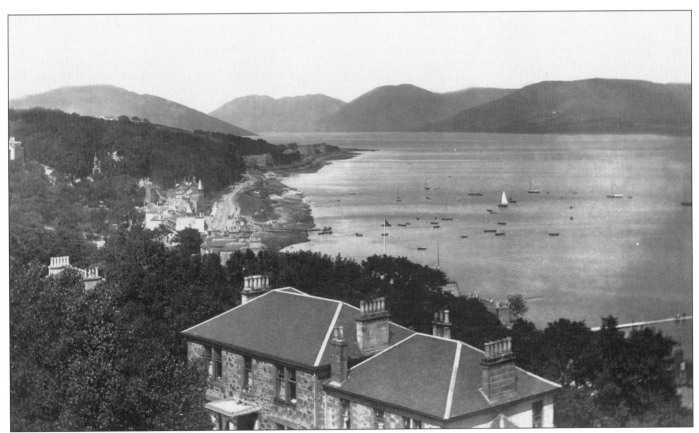

PIC39843A THIS IS ARDBEG POINT IN 1897, WITH LOCH STRIVEN IN THE DISTANCE. The entrance to the Kyles of Bute is just beyond the headland.

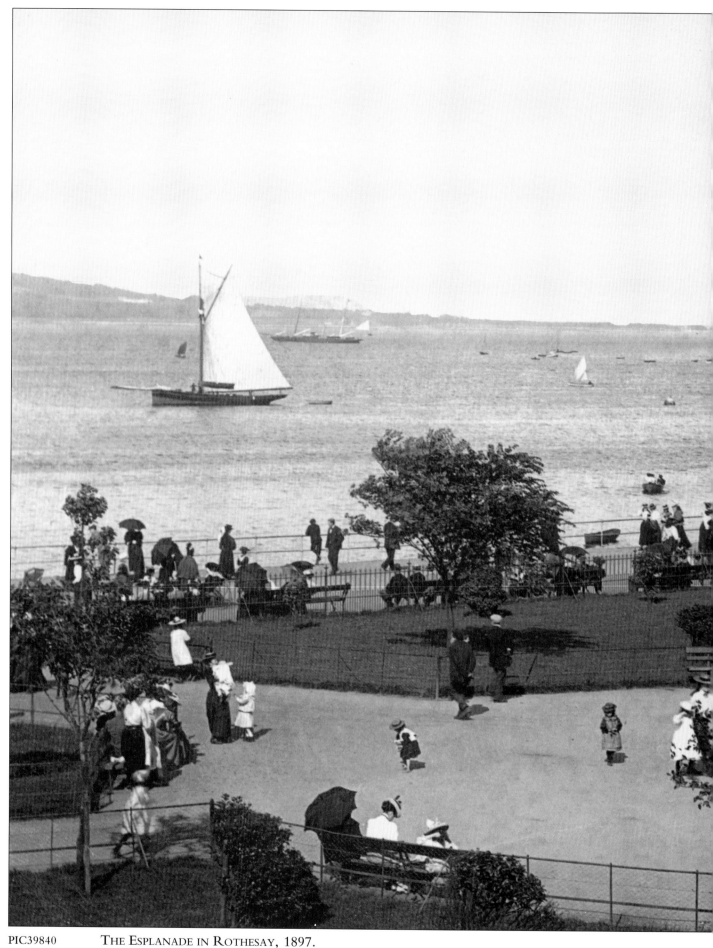

PIC39840 THE ESPLANADE IN ROTHESAY, 1897.

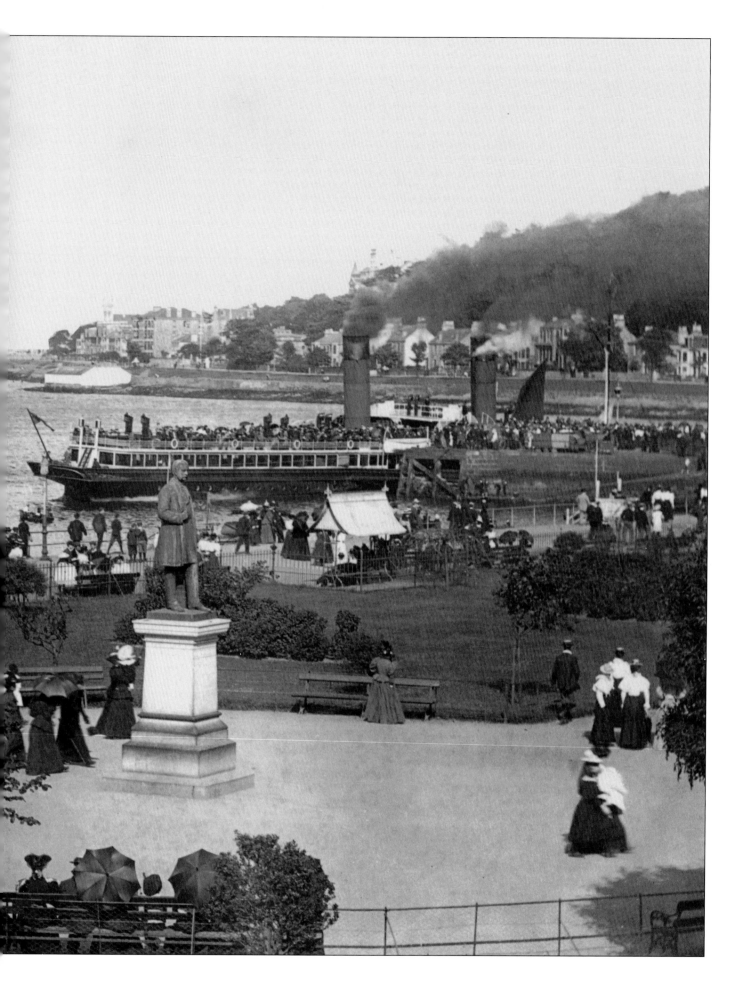

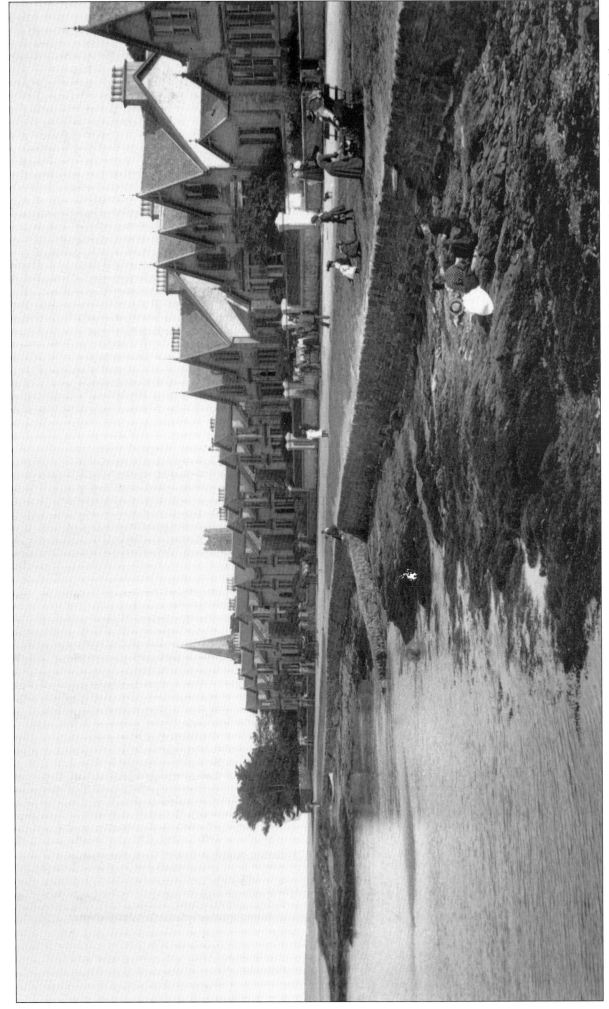

LOCH FAD IS THE LARGEST INLAND STRETCH OF WATER ON BUTE. On the western shore stands the regency-style house built in 1827 by the actor Edmund Kean.

PIC52610

LARGS

The bustling holiday town of Largs has long been famous as the site of a great battle in 1263, in which 16,000 Norwegians and 5,000 Scots were killed. Well there was certainly a battle and if there were any casualties they were very light. King Haakon of Norway's fleet had entered the Firth of Clyde when a storm drove ten supply ships onto the beach at Largs. The crews and the Scots fired a few arrows at one another, but packed in when night fell. The following morning Haakon himself landed on the beach with reinforcements, but instead of just facing a few locals he found Alexander III's army. There was no pitched battle, only a couple of poorly co-ordinated charges of horses along the beach. The Scots then withdrew and the Norwegians sailed away. Largs was important however, in that it led in the Treaty of Perth, under which Man and the Western Isles were purchased by the Scottish crown for 4,000 marks and an annual rent of 100 marks.

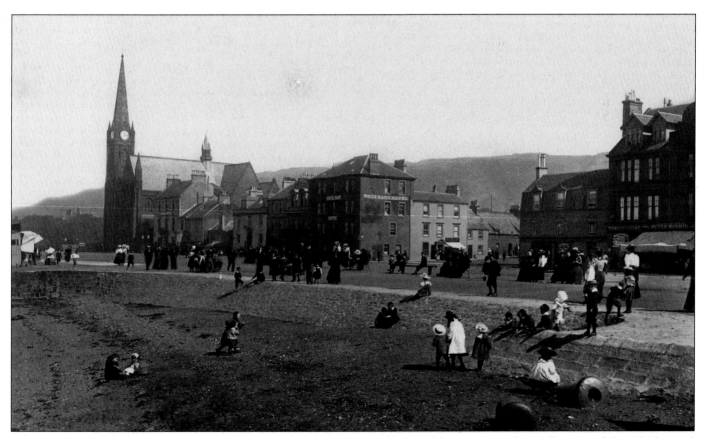

PIC39856 VIEW OF LARGS FROM THE BEACH. Largs was well served by steamers from all parts of the Clyde, and by the Glasgow & South Western Railway route to Ardrossan via Fairlie and West Kilbride. One of Largs' own well-travelled sons was Sir Thomas Brisbane, who became governor of New South Wales and had an Australian city named after him.

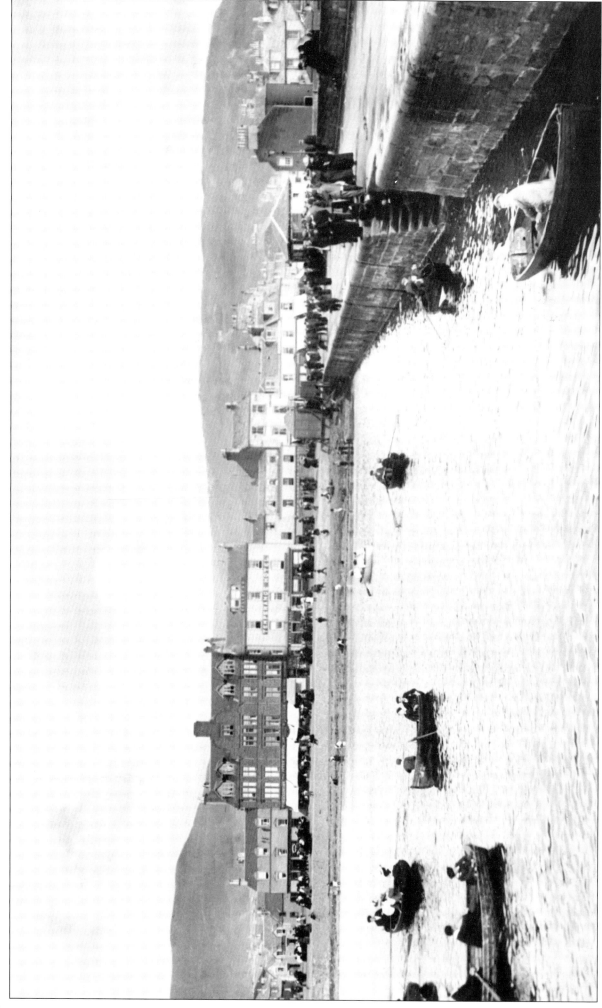

PIC39851 SHELTERED BY THE NEARBY ISLAND OF CUMBRAE, LARGS WAS AND STILL IS A POPULAR PLACE FOR MESSING ABOUT IN BOATS. It was also a good centre for excursions by steamer to the Kyles of Bute, Loch Fyne and the Kilbrennan Sound.

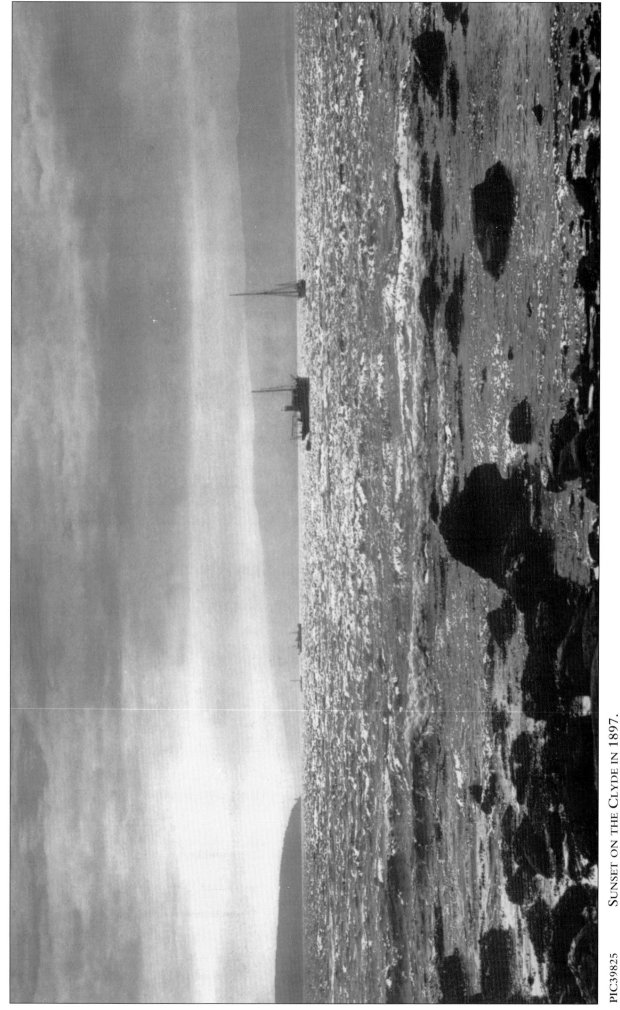

Sunset on the Clyde in 1897.

PIC39825

Pictorial Memories Collection

A great new range of publications featuring the work of innovative Victorian photographer Francis Frith.

∽ 1998 Titles ∽

County Series		£9.99
1-84125-045-7	Berkshire	
053-8	Buckinghamshire	
024-4	Derbyshire	
077-5	Greater London	
028-7	Kent	
029-5	Lake District	
051-1	Lancashire	
031-7	Leicestershire	
026-0	London	
027-9	Norfolk	
030-9	Sussex	
063-5	West Yorkshire	
025-2	Yorkshire	

Town & City Series		£9.99
010-4	Brighton & Hove	
015-5	Canterbury	
079-1	Edinburgh	
012-0	Glasgow & Clydeside	
081-3	Norwich	
040-6	York	

Country Series		£9.99
1-84125-075-9	Ireland	
071-6	North Wales	
073-2	Scotland	
069-4	South Wales	

Poster Books		£4.99
000-7	Canals and Waterways	
032-5	Derbyshire	
001-5	High Days and Holidays	
036-8	Kent	
037-6	Lake District	
034-1	London	
005-8	Railways	

		£5.99
023-6	Canterbury	
043-0	Derby	

∽ Titles from January to July 1999 ∽

County Series		£9.99	
1-84125-049-x	Warwickshire	March	
047-3	Staffordshire		
057-0	Devon		
067-8	Cheshire		
065-1	Nottinghamshire		
059-7	Cornwall		

1-84125-101-1	Surrey		
095-3	Hampshire		
128-3	Highlands	April	
149-6	Hertfordshire		
130-5	North Yorkshire	May	
150-x	Wiltshire		

Town & City Series		£7.99	
089-9	Maidstone	March	
087-2	Bradford		
083-x	Colchester		
093-7	Dublin		
091-0	Leeds		
105-4	Buxton		
111-9	Bristol		
113-5	Nottingham		
011-2	Manchester		
107-0	Matlock		
009-0	Macclesfield	April	
132-1	St Ives		
008-2	Derby		
133-x	Sevenoaks		
014-7	Newbury		
134-8	Bognor Regis		
144-5	Leicester		
145-3	East Grinstead		
146-1	Newark		

137-2	Sheffield	May	
138-0	Cambridge		
139-9	Penzance		
140-2	Eastbourne		
147-x	Llandudno		
142-9	Torquay		
148-8	Whitby		
159-3	Scarborough	June	
160-7	Faversham to Herne Bay		
164-x	Scilly Isles		
162-3	Dorset Coast		
168-2	Falmouth		
165-8	Newquay		
154-2	Bakewell	July	
163-1	Lincoln		
167-4	Barnstaple		
174-7	Great Yarmouth		
141-0	Blackpool		
207-7	Dartmoor		

WATERTON PRESS, WATERTON ESTATE, BRIDGEND, GLAMORGAN, CF31 3XP.
TEL: 01656 668836 FAX: 01656 668710